Botanical Illstration in Gouache

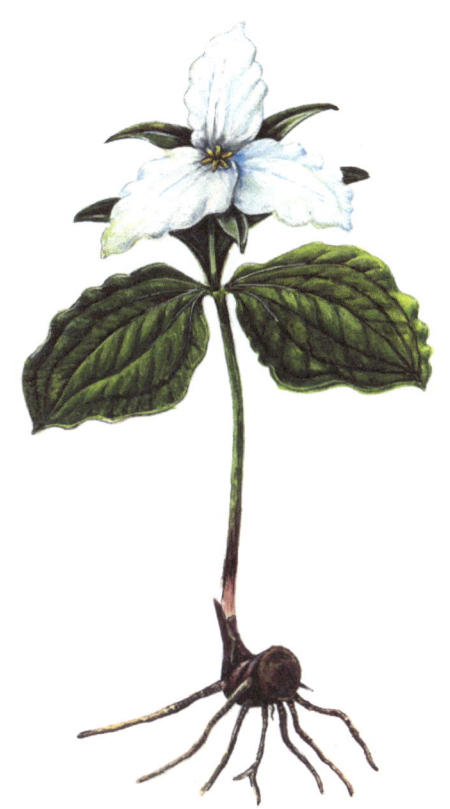

Written and Illustrated
by
Sandy Williams

© Sandra L. Williams 2011

Index

Introduction .. 1
Parts of a Plant .. 2
Gouache .. 3
Materials List .. 4
Before You Begin (Health and Safety) ... 5
Part 1 .. 6
 Blending Exercise ... 7
 Four Colorful Flowers (color copy) 8
 Four Colorful Flowers (black and white copy) 9
 Coreopsis ... 10
 Morning Glory ... 12
 Poppy ... 15
 Blanket Flower .. 17
Notes .. 20
Part 2 ... 21
 Trillium grandiflora (color copy) 22
 Trillium grandiflora (black and white copy) 23
 Stem .. 24
 Leaves .. 25
 Roots ... 28
 Petals .. 29
 Cutaway View and Ovary .. 31
 Overhead View ... 33
Notes .. 35
Part 3 -- On Your Own .. 36
 Questions to Ask .. 37
Notes .. 38
Wrapping Things Up ... 39
Notes .. 40

Introduction

Flowers decorate our lives throughout the year, from the first crocus of springtime to the dried weeds in the depths of winter. I grew up in a family of gardeners and was privileged to be surrounded by flowers in every color, size and shape. It was only natural for me, as I developed into an artist, to gravitate toward botanicals as one of my subjects.

I ultimately settled on gouache as the medium that could best capture all the details of my botanical subjects, right down to the hairs on the stems.

What is a good botanical illustration? Above all, it must be ACCURATE. It must depict as many different aspects of a plant as possible, as concisely as possible, while keeping the beauty of the plant intact. In this course I can show you one way to prepare an illustration. My way is not the only way, or necessarily the best or easiest way, but it's the one that works for me. I hope to introduce you to the techniques and materials you can use for botanical illustration, and as a result I hope to inspire you to explore and see what works best for you.

Don't forget! First and foremost a good botanical illustration is an ACCURATE portrayal of a plant. ACCURACY through OBSERVATION! That's first and a good aesthetic quality is second. Please note that you don't need to have a degree in botany to be able to create a good botanical illustration. You don't have to know what something is called to be able to paint it, although it helps if you need to discuss it with someone else. Sometimes you'll need to work with scientific names of specimens. Remember that the first word of the two word name is capitalized and the second word is always lower case, as in Trillium grandiflora.

So, the goal of this course is to give you the basic knowledge of tools, materials and techniques of using gouache to ACCURATELY portray a botanical subject through OBSERVATION!

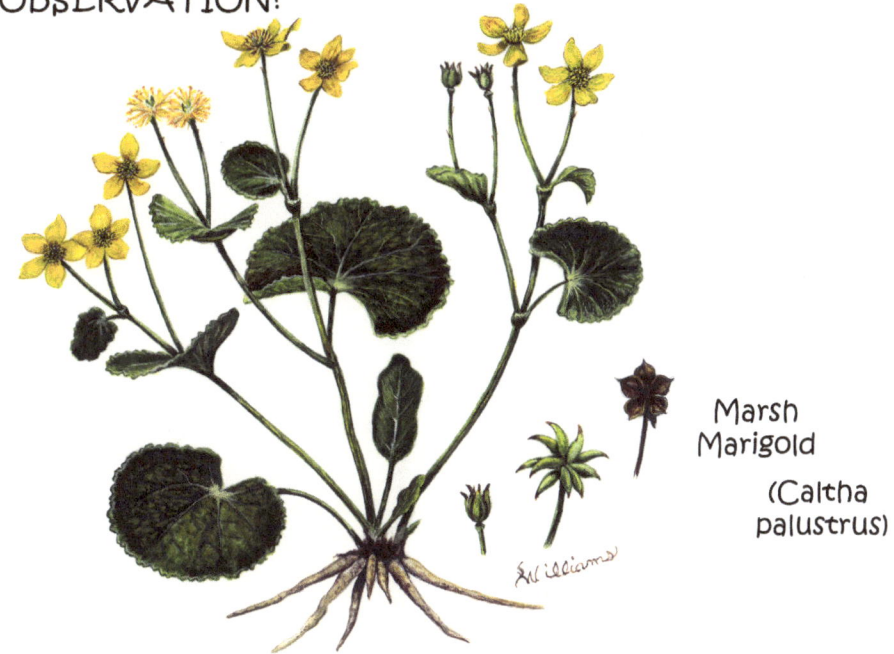

Marsh Marigold

(Caltha palustrus)

Parts of a Plant

You don't have to know what the individual parts of a plant are named to be able to paint them. However, if you need to discuss your illustration with someone else you'll need to have some way to describe what part of the plant you're talking about. So... here are some of the names of the parts of a plant.

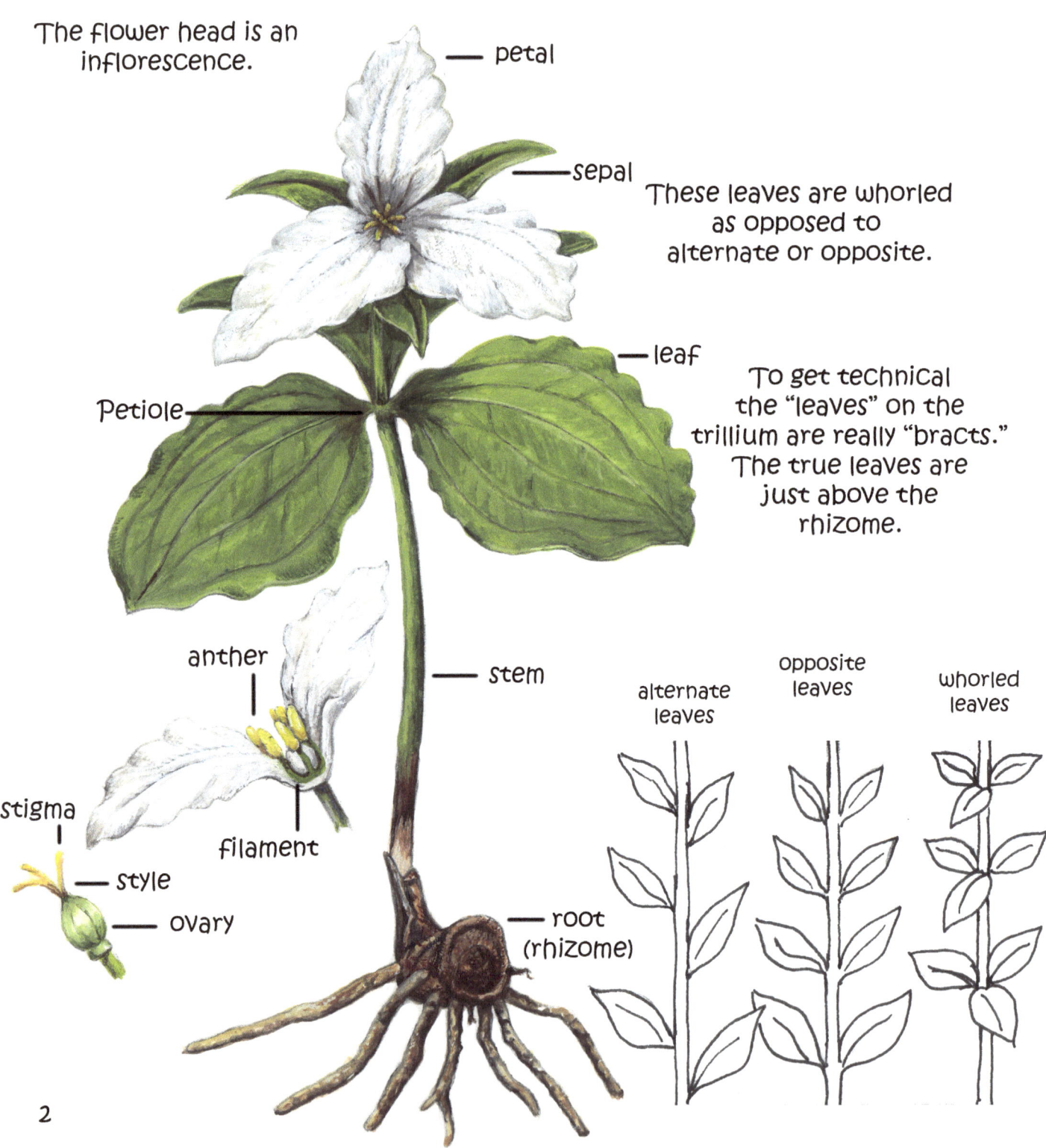

Gouache

Gouache is an opaque watercolor. The pigments are bound by a liquid glue, like Gum Arabic, and white pigment or chalk is added for more opacity. It has an almost suede like finish and lines painted with gouache can be very sharp. The colors can be brilliant or very subtle. It has a centuries old history and has been used for anything from illuminated manuscripts to modern commercial advertising work.

There are many brands of gouache available. I use mostly Winsor & Newton because it's easy to find and of good quality. Other brands are M. Graham, Holbein, Schmincke and Daler Rowney.

The first time you use gouache squeeze a small amount of color onto your palette. Even though you don't use it all up right away you'll be able to reconstitute it with water for later use. The only time this won't work is when you have a large area to cover. Use fresh paint for that or you'll get little lumps of undisolved paint in yur piece. If that happens brush them off and touch up.

Don't add a lot of water to the paint, or fill up the paint well on your palette with water. Water is added to the paint a little at a time by dipping your brush in water and then working it into one side of your spot of paint. The paint should have a creamy consistency. If you add too much water the paint will lose its opacity. The colors can be mixed in another well on the palette or, sometimes, directly on the painting.

One of the great advantages of gouache is that it's very "forgiving." If you find that a certain area is not working just paint over it and start again.

Start by squeezing out spots of paint about this size

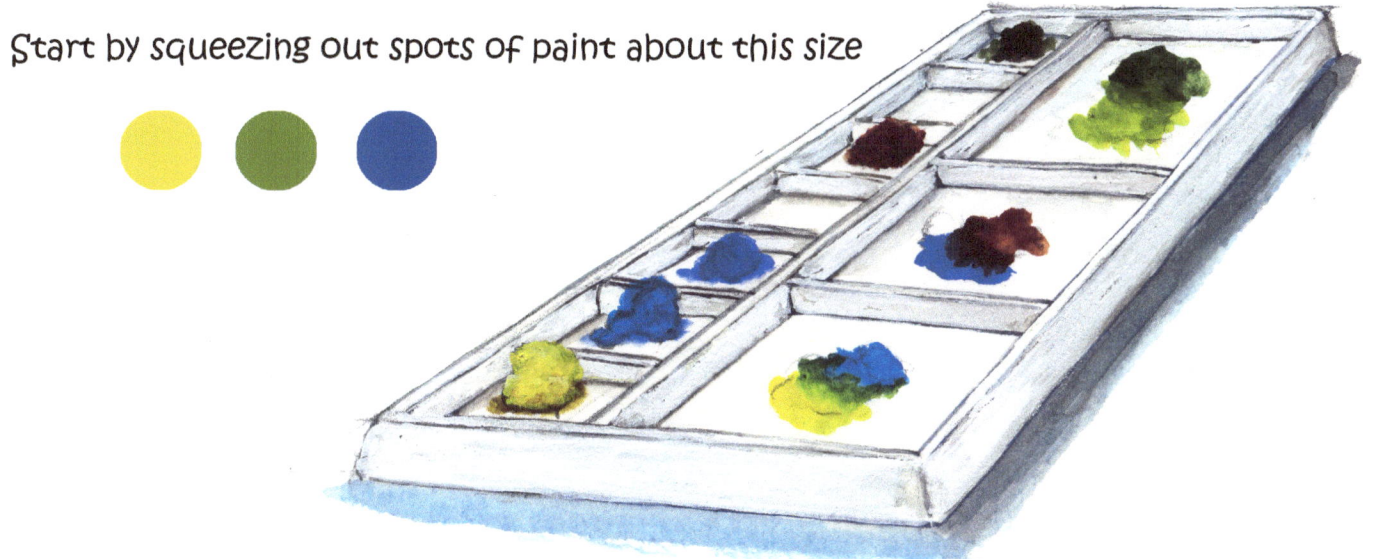

Materials List

PENCILS -- I generally use a softer pencil, like a 4B, to draw with but use whatever you're comfortable with. Just make sure that you don't make your marks so hard that they're hard to erase. I use a kneaded eraser because it won't leave little crumbly bits of material that have to be brushed off.

PAPER -- I recommend using hot press watercolor paper, preferably 140 #, although a little lighter weight would be OK, too. Some artists use illustration board, vellum or bristol. I use Arches 140# hot press because it has a nice, smooth surface to make detailing easier and crisper looking. Experiment and try some different papers. One standard size sheet should be plenty for this course.

PALETTE -- It should be white so you can see exactly what color you're mixing. If you don't have a palette a white paper plate works fine. It's just a little harder to transport wet paint if you have to move around.

WATER CONTAINER -- Use whatever you have on hand. At home I use 5 ounce disposable Dixie cups -- no breakage problem and no clean up, but bad for the landfill.

TRANSFER PAPER -- Depending on how you transfer your images you may or may not need some plain tracing paper. An 11" x 14" sheet folded in half should do.

BRUSHES -- You'll probably need three small watercolor brushes: a 4/0 small round, a #1 small round and an 18/0 liner brush

GOUACHE -- The eight tubes listed here will give you enough variety of colors to complete all the illustrations in this course. The brand I use is Winsor & Newton but that's not a requirement.

- Permanent White
- Olive Green
- Burnt Umber
- Burnt Sienna
- Primary Blue
- Ivory Black
- Ultramarine Blue
- Primary Yellow

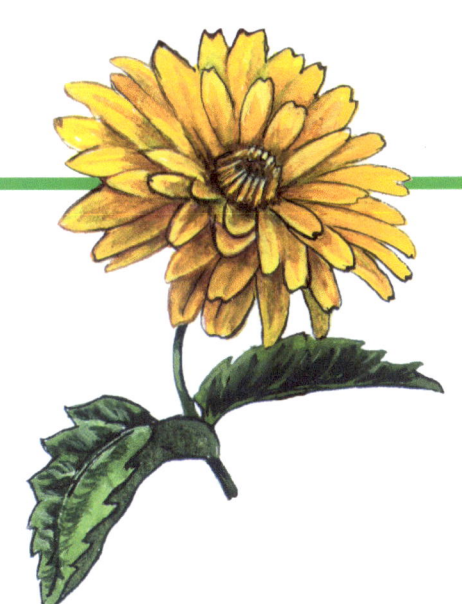

Before You Begin

Here are a few tips on health and safety.

BE AWARE! Some of the pigments we work with are poisonous. Visit a site like http://www.ci.tucson.az.us/arthazards for specific information on the pigments or processes you use.

For this course please remember three things.

1. Don't put the tips of your brushes in your mouth!

2. Wash your hands after painting before you eat.

3. Get up and stretch frequently. Besides loosening up your body you'll come back to your painting with fresh eyes and it will be easier to see the progress you've made and what has yet to be done.

PART 1

The first exercises are designed to help you master the basic techniques of painting with gouache.

For the Blending Exercise sketch the stem and petal on a small piece of watercolor paper. Don't worry about getting the drawings exact. This is just an exercise to learn about handling the paint.

For the Four Colorful Flowers Exercise please note that there's a black and white copy of the outline of the flowers included with the course material. Use it to transfer an outline of the four flowers to a piece of hot press (smooth surface) watercolor paper.

Transferring an image

There are several ways to transfer images to paper. If you have a light box just place the flower outline sheet on the glass, place your watercolor paper over it and trace with a pencil. You can also use a window to do the same thing. Tape the flower outline sheet to the window, tape your watercolor paper over that, and trace. You could also use a soft pencil and rub graphite onto the back of the flower outline sheet. Then place the sheet on top of your watercolor paper and firmly trace the outlines onto the paper. Or. . . and this is the way I generally do it. . . you can take a sheet of tracing paper and cover half of it with graphite from a a soft pencil. When not in use fold the tracing paper over on itself to cover the side with the graphite so it won't smear all over. When you're ready to use it place it, graphite side down, on your watercolor paper. Place your flower outline sheet on top and trace firmly. I've used the same sheet of tracing paper for this process for over ten years. I just keep adding more graphite when my tracings get too light.

Something to keep in mind --

With gouache it's often the case that the edges of the flowers, leaves or stems will be too sharp and the illustration will look "pasted on" the page. You'll need to take a damp brush and gently soften the edges, either as you go along or at the end, whatever works best for you.

Blending Exercises

(1)

Draw a simple stem shape--smaller than this example. Paint it with a mixture of Olive Green, Brilliant Yellow and White. Don't worry about making straight lines or even tones. This is just an exercise.

(2)

Paint a mixture of Burnt Umber and Ultramarine Blue along the top and down the right side. Using a damp brush blend the line where the two colors meet to soften it.

(3)

Paint a highlight of mostly white with a little yellow added to it on the left side of the stem. Blend it in with a damp brush.

(1)

Draw a rough petal shape. Paint it with a somewhat thin layer of Burnt Sienna. Don't try to be perfect. This is just an exercise.

(2)

Paint Brilliant Yellow on the upper ridges of the petal. Make sure the paint has a creamy consistency.

(3)

Blend the yellow into the Burnt Sienna. Add white to the upper parts of the ridges for a highlight. Blend it in with a damp brush.

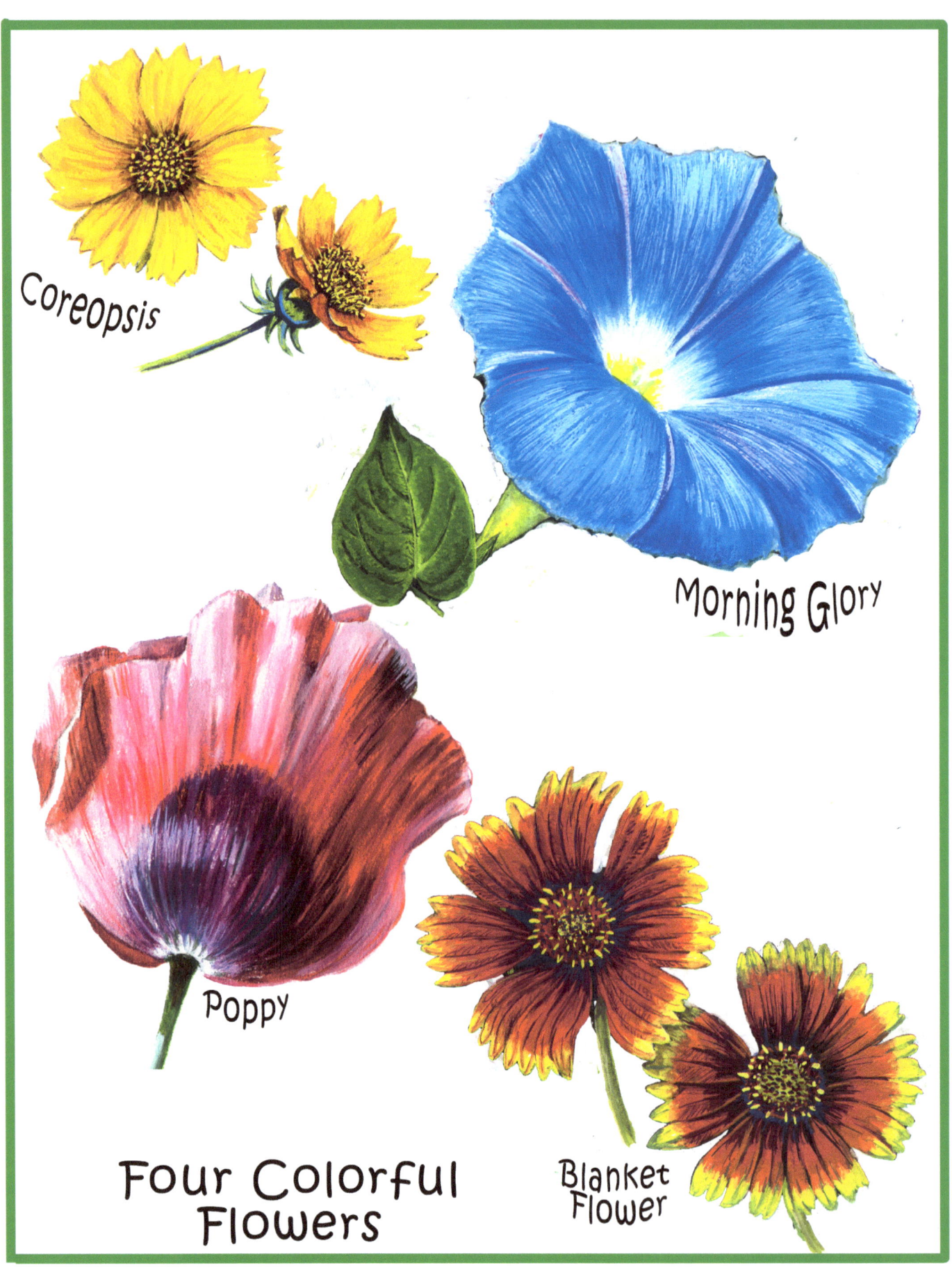

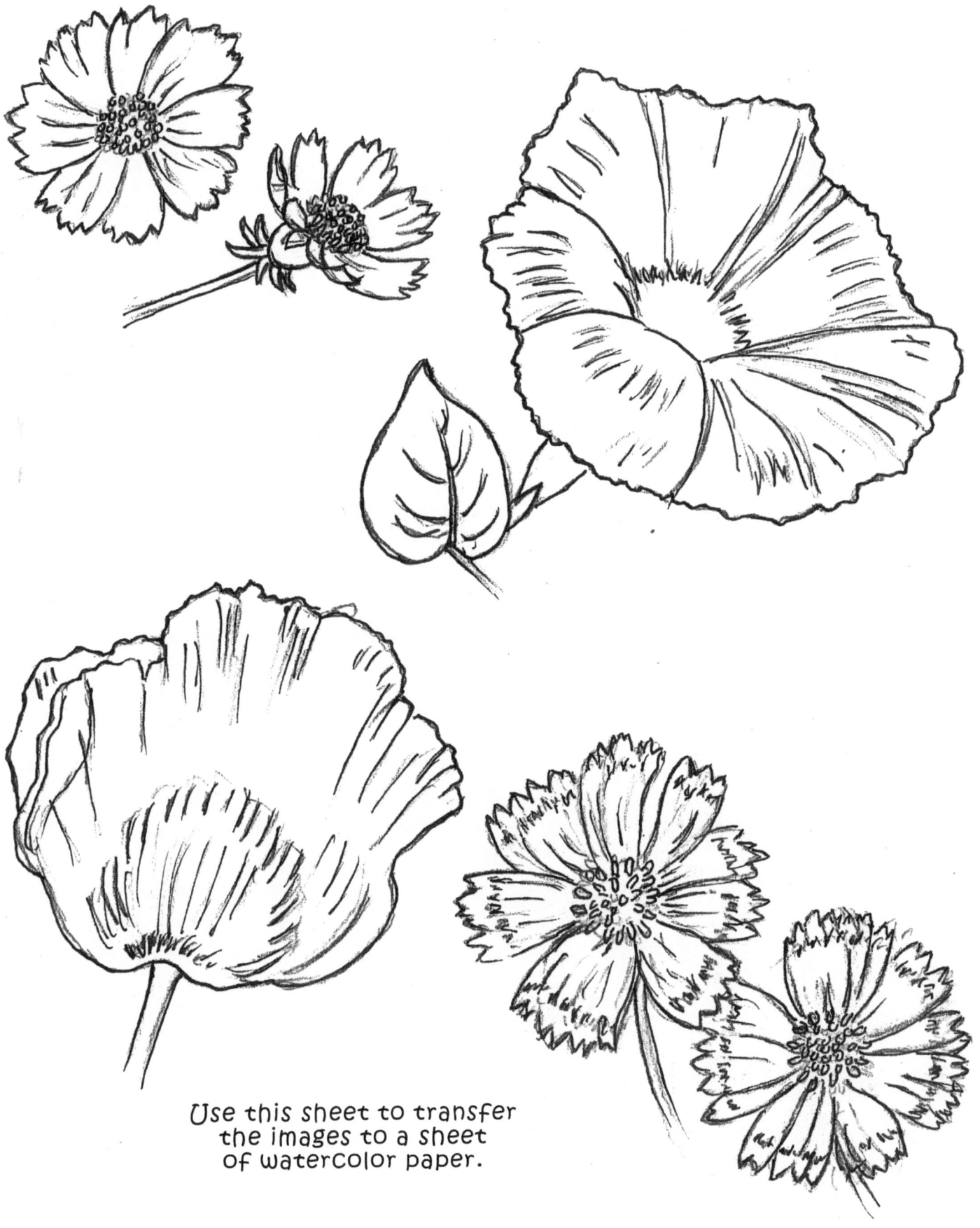

Use this sheet to transfer the images to a sheet of watercolor paper.

Coreopsis

Colors: Burnt Sienna, Burnt Umber, Ultramarine Blue, Brilliant Yellow, Permanent White

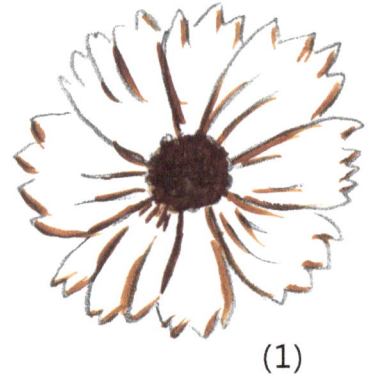

(1)

Paint the lines radiating out from the center and the petal tips with Burnt Sienna. Paint the center with a dark mixture of Burnt Sienna and Ultramarine Blue

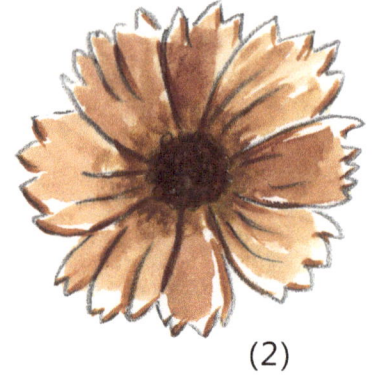

(2)

Put a thin layer of Burnt Sienna over the entire flower, a little darker toward the center

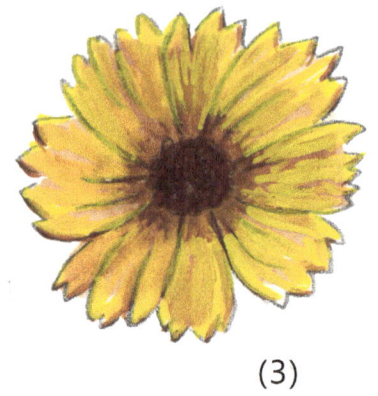

(3)

Paint in the Brilliant Yellow starting your strokes near the center and going outward toward the petal edges. Leave some of the Burnt Sienna showing through, especially near the center. Don't paint over all the lines that separate the petals.

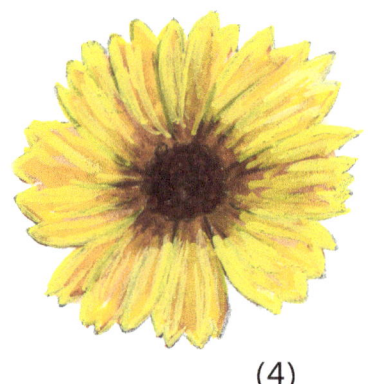

(4)

Mix Brilliant Yellow with White and repeat the process of brushing on the light value from near the center outward toward the edges of the petals. Be sure to leave a little of the two previous layers showing. Make sure there's only the faintest hint of a dark value showing on the outside edges of the petals.

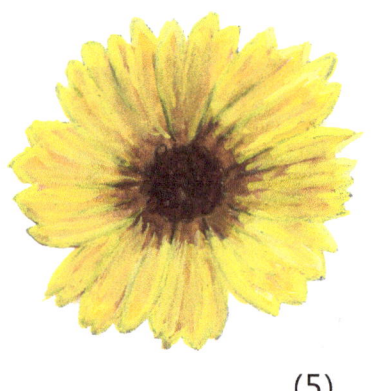

(5)

With a damp brush gently blend the strokes from the center to the edges. Don't blend too much. You still want the previous layers to show.

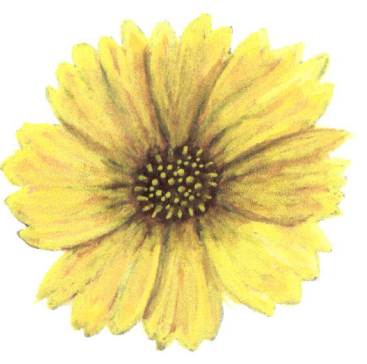

(6)

Blend the yellow of the petals into the Burnt Sienna toward the center. Restate some of the lines dividing the petals into eight sections. With a thick yellow paint finish the center with dots and dashes (on the outer edge of the circle). Blend the edges of the dashes toward the center.

Coreopsis -- Side View

Colors: Olive Green, Brilliant Yellow, Permanent White, Burnt Sienna, Burnt Umber, Ultramarine Blue

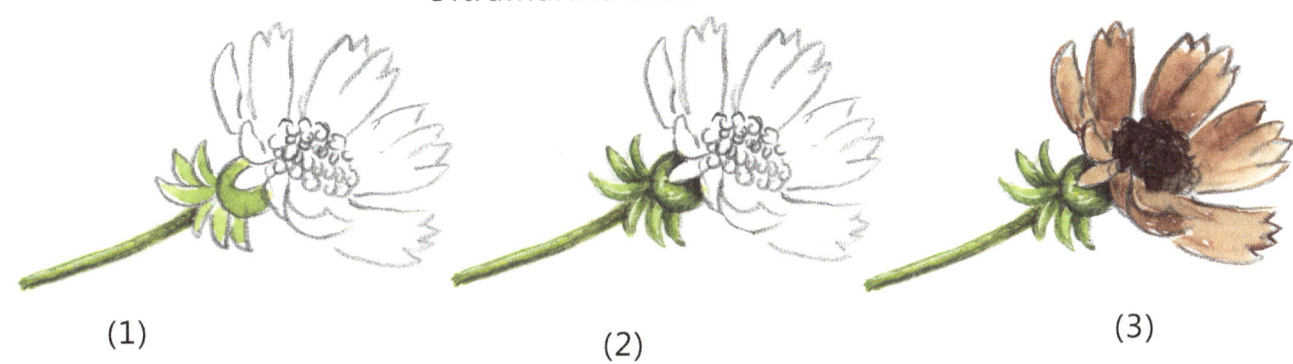

(1) Mix Olive Green, Brilliant Yellow and Permanent White to make a pale green for the stem. Mix Ultramarine Blue and Burnt Umber and paint the shadows on the lower side of the stem and where the stem meets the sepals. Highlight the upper side of the stem with a mixture of Brilliant Yellow and White. Blend. Paint the ovary and sepals light green.

(2) Add a dark green value on the edges of the leaves and where the shadow falls on them toward the center. Also shade and highlight the ovary.

(3) Paint the lines on the petals with Burnt Sienna. Put a thinner coat of Burnt Sienna over all the petals. Paint the center dark with a mixture of Burnt Sienna and Ultramarine Blue.

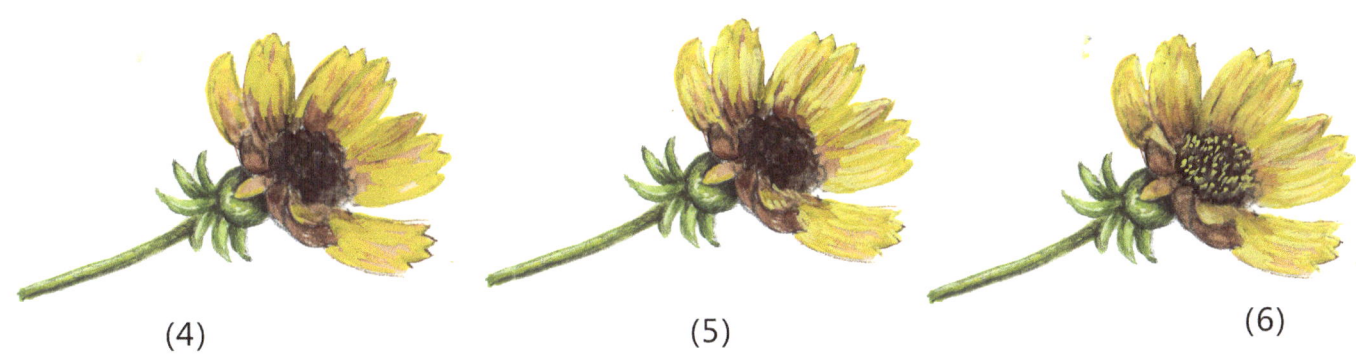

(4) Paint the petals with a thick layer of Brilliant Yellow, stroking from the center outward to the edges of the petals, almost covering the Burnt Sienna. Don't completely cover the underlayer. Leave just a hair's breadth of a dark outline on the petals" edges.

(5) Paint a mixture of Brilliant Yellow and White on the petals, stroking from the center outward, letting the two previous layers show through in places. Gently blend the layers together a little. Leave the twisted petals closest to you mostly Burnt Sienna so they'll show up.

(6) Using thick Brilliant Yellow detail the center of the flower with dashes and dots, blending the bottoms into the dark value.

Morning Glory

Colors: Olive Green, Brilliant Yellow, Permanent White, Primary Blue, Ultramarine Blue

(1)

(2)

Mix a light value of a mixture of Olive Green, Brilliant Yellow and White. Paint the bottom of the throat of the flower. Add a little Ultramarine Blue to make the shadow color and a little pale yellow green on top for a highlight.

Paint the small green leaf on the bottom of the throat (the sepal) with Olive Green highlighted with a pale yellow green. Paint the stem on the leaf with a medium value green, highlighted with yellow green and shaded with a little Ultramarine Blue at the top and on the lower side of the stem. With a dark value of a mixture of Olive Green and Ultramarine Blue paint in the leaf veins so you don't lose them when you paint in the rest of the leaf.

(3)

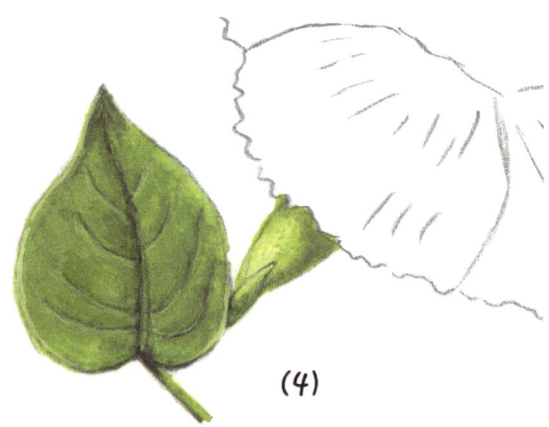

(4)

Paint a thinner layer of medium green on the leaf. Paint a thin shadow along the main vein.

Then go over the whole leaf with green in a creamy consistency, almost covering the dark veins. Put a narrow highlight along the leaf veins using white added to the green. Also highlight the edge of the leaf to give it weight.

Use Ultramarine Blue to paint the dark lines on the flower so you don't lose them when you paint the rest of the flower. This time don't outline the edges of the petals. The blue will be dark enough so that the petals won't be too hard to see on the white of the paper (like the coreopsis). Paint the interior of the throat Brilliant Yellow.

(5)

Use Primary Blue to paint he petals, stroking from the throat to the edges. Primary Blue, straight out of the tube, is much too dark so add White. Cover all the blue parts of the petals but don't try to be perfect. Just cover up the white. The only place you need to be careful is on the outside edges of the petals. Paint them carefully.

(6)

Begin to go over the petals again with more careful strokes, still going from the center outwards, using your liner brush for the narrowest strokes possible. Add more white to the paint ixture toward the outer edges or where there's a highlight. This can be time consuming and you may have to go around the flower several times.

(7)

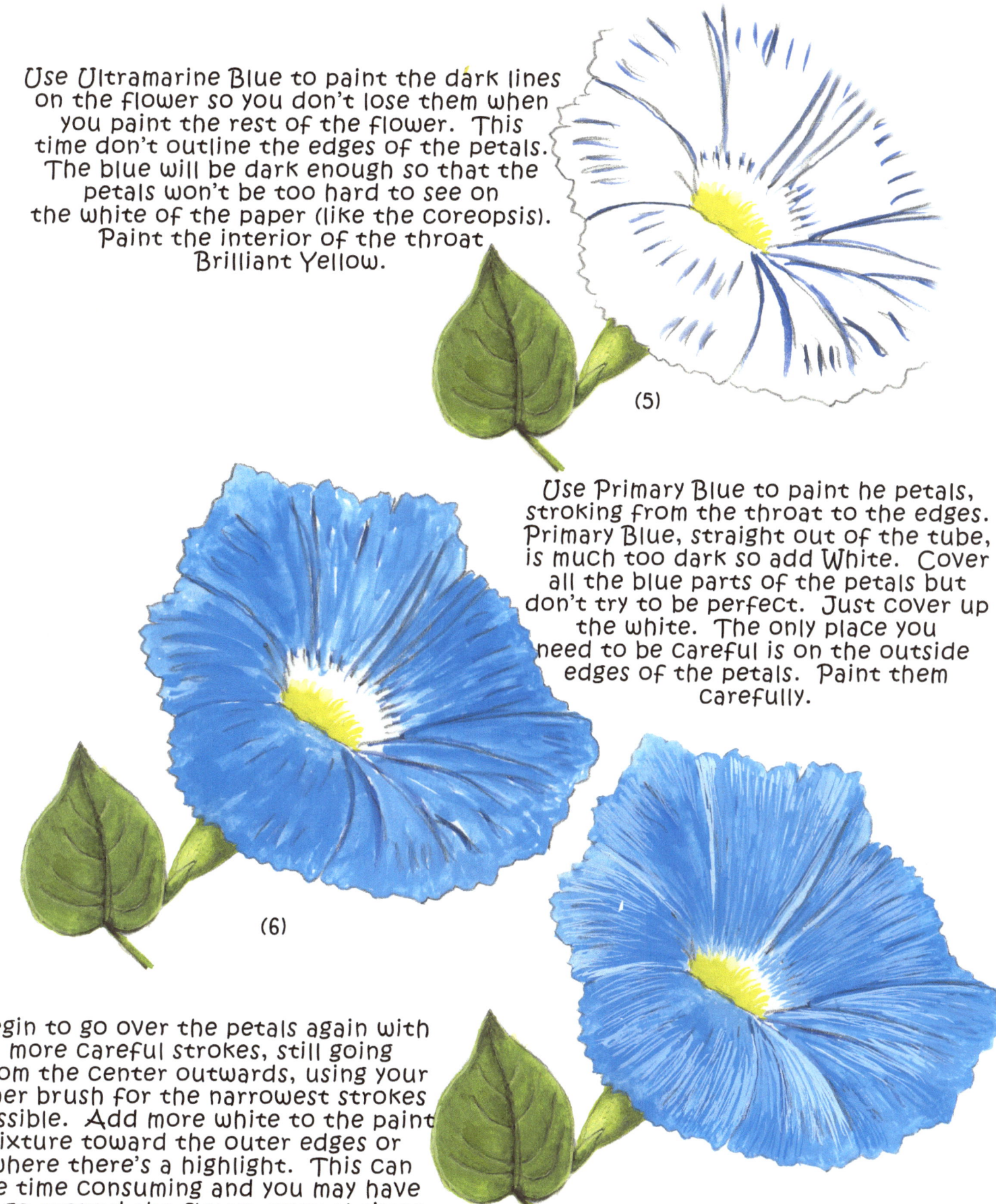

13

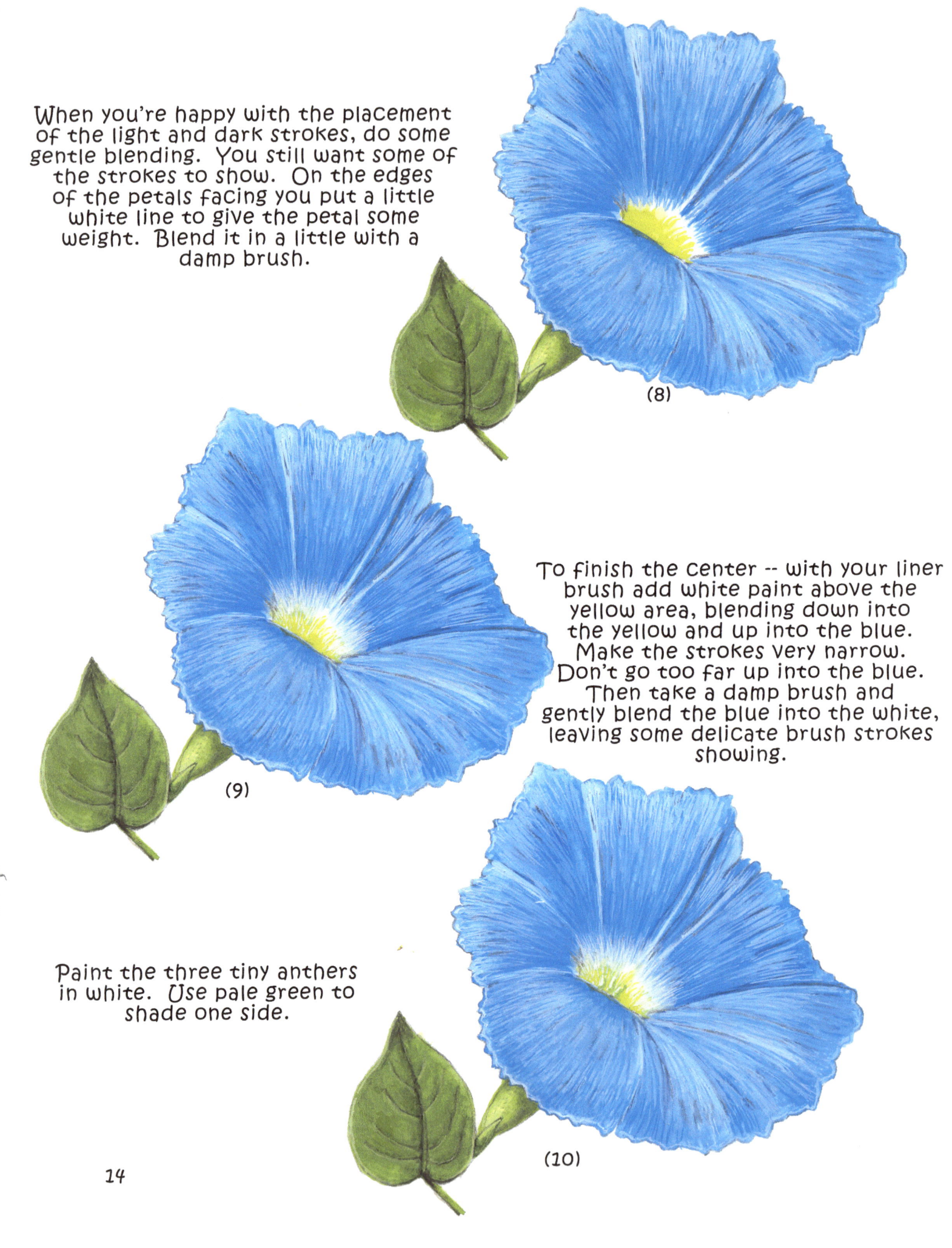

When you're happy with the placement of the light and dark strokes, do some gentle blending. You still want some of the strokes to show. On the edges of the petals facing you put a little white line to give the petal some weight. Blend it in a little with a damp brush.

(8)

To finish the center -- with your liner brush add white paint above the yellow area, blending down into the yellow and up into the blue. Make the strokes very narrow. Don't go too far up into the blue. Then take a damp brush and gently blend the blue into the white, leaving some delicate brush strokes showing.

(9)

Paint the three tiny anthers in white. Use pale green to shade one side.

(10)

Poppy

Colors: Olive Green, Brilliant Yellow, Permanent White, Bengal Rose, Primary Blue, Ultramarine Blue, Burnt Umber

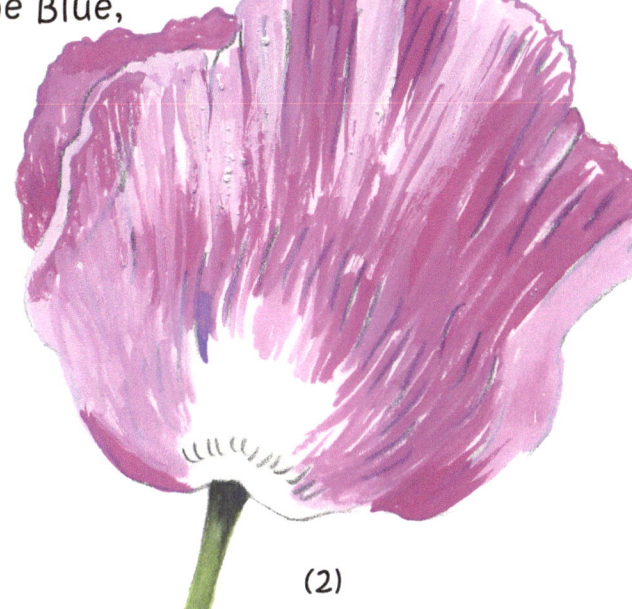

(1) Paint the stem with a mixture of Olive Green, Brilliant Yellow and White. Add Ultramarine Blue for the shadow at the top. Blend. Add a light value highlight. Blend.

(2) Bengal Rose is an intense color. Add a lot of white and stroke the paint from the bottom (leaving the dark spot white) to the top, varying the mixture so it's not all the same color and value. Take your time on the outside edges of the petals and try to get them exact.

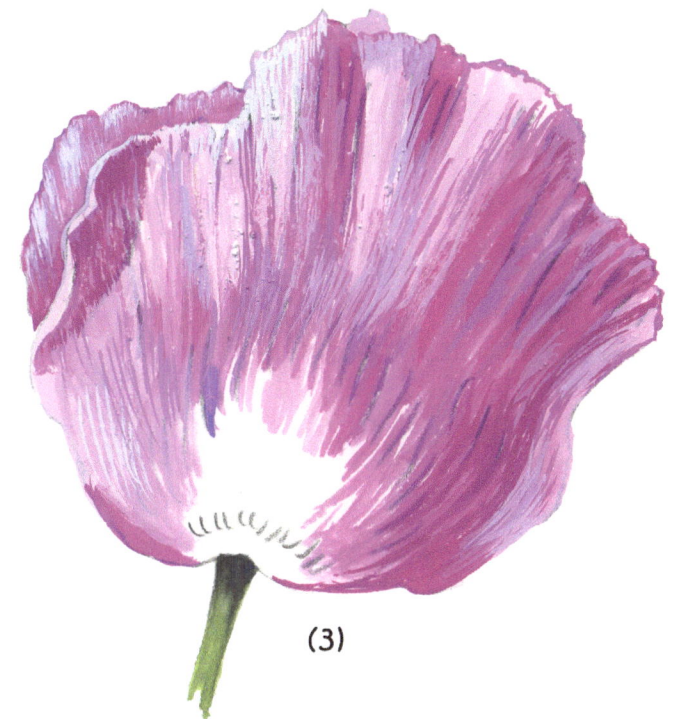

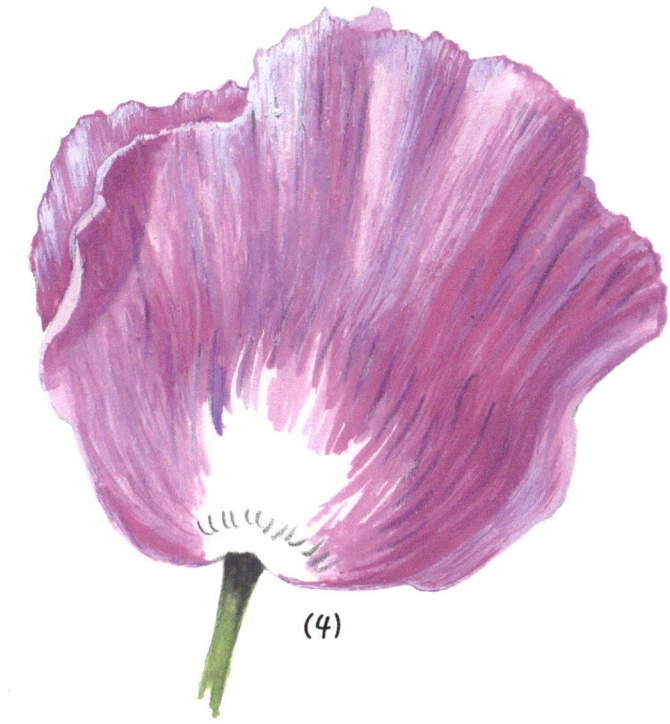

(3) Paint a lighter value where the light hits the petals. Here it's from the left side. Paint a darker value of mostly Bengal Rose on the side away from the light. Here it's on the right.

(4) When you have the values the way you want them, begin gently blending them with a damp brush. Don't blend the lines out completely. Also, soften the edges of the petals so the flower doesn't look pasted on the paper.

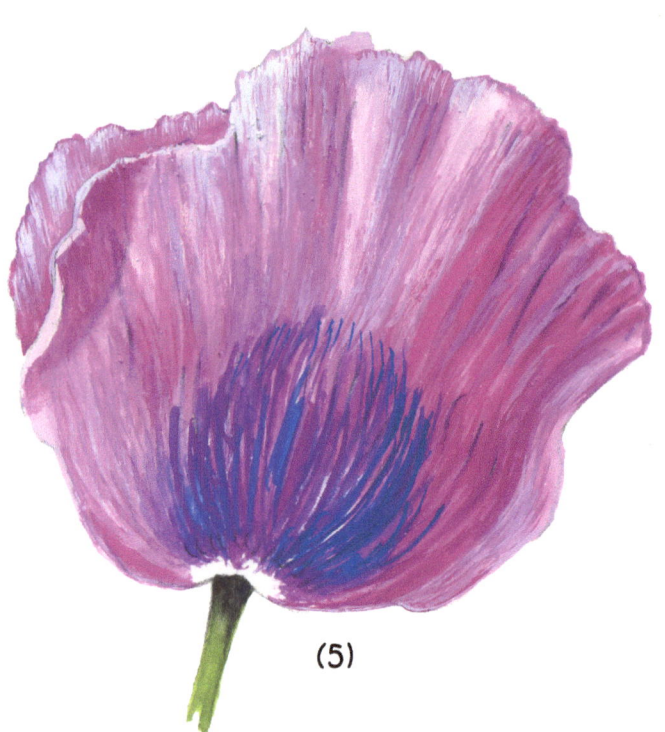

(5)

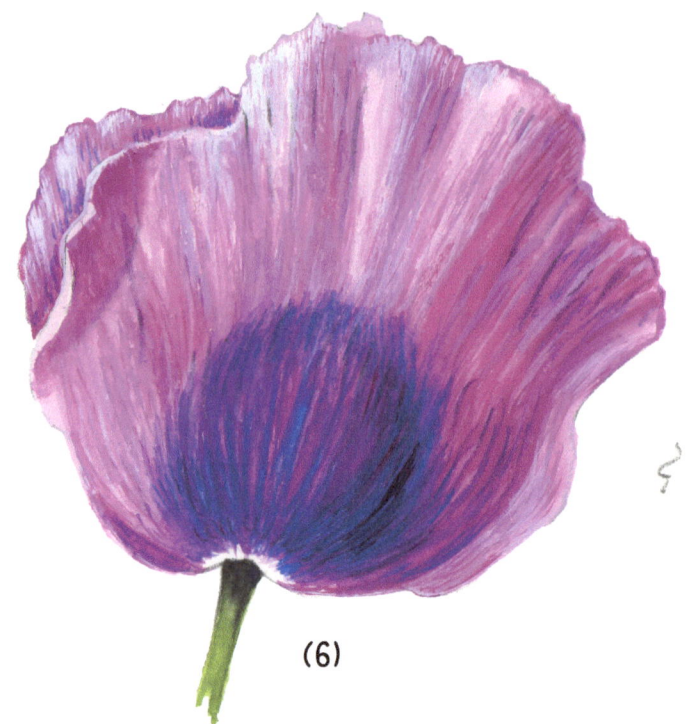

(6)

Start painting the darker spot on the petal. Mix Bengal Rose, Primary Blue and a little White for the medium tones. Add a little Ultramarine Blue for the darker areas on the right, moving your brush along the contours of the flower.

For the very darkest values add a small amount of Burnt Umber to the Ultramarine Blue. With a damp brush blend, being careful not to lose all your vertical lines.

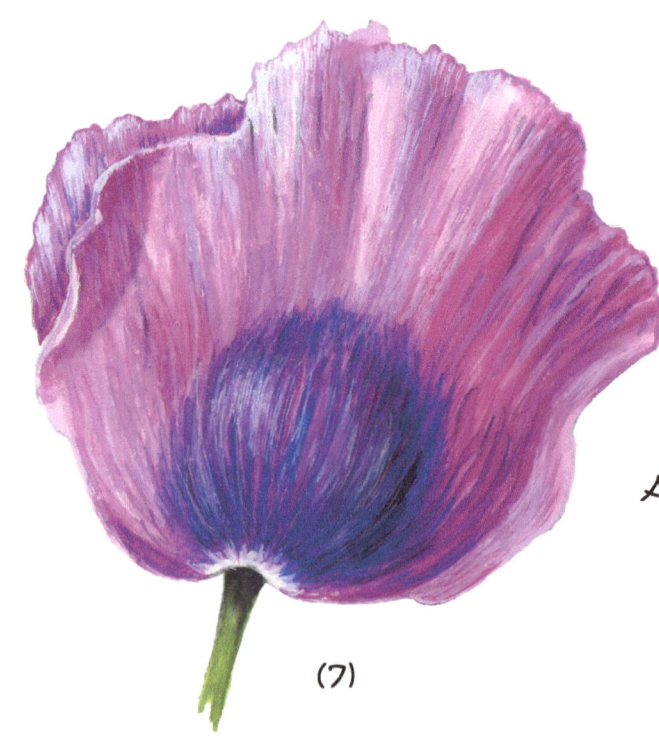

(7)

Use pure Permanent White to highlight the left side of the purple spot. When you blend it in it will change to light pink or violet. Be sure to keep a little almost pure white in the lightest spot. Also, add white at the bottom of the flower, above the stem. Blend upwards.

Blanket Flower

Colors: Olive Green, Brilliant Yellow, White, Ultramarine Blue, Burnt Sienna, Burnt Umber, Primary Red

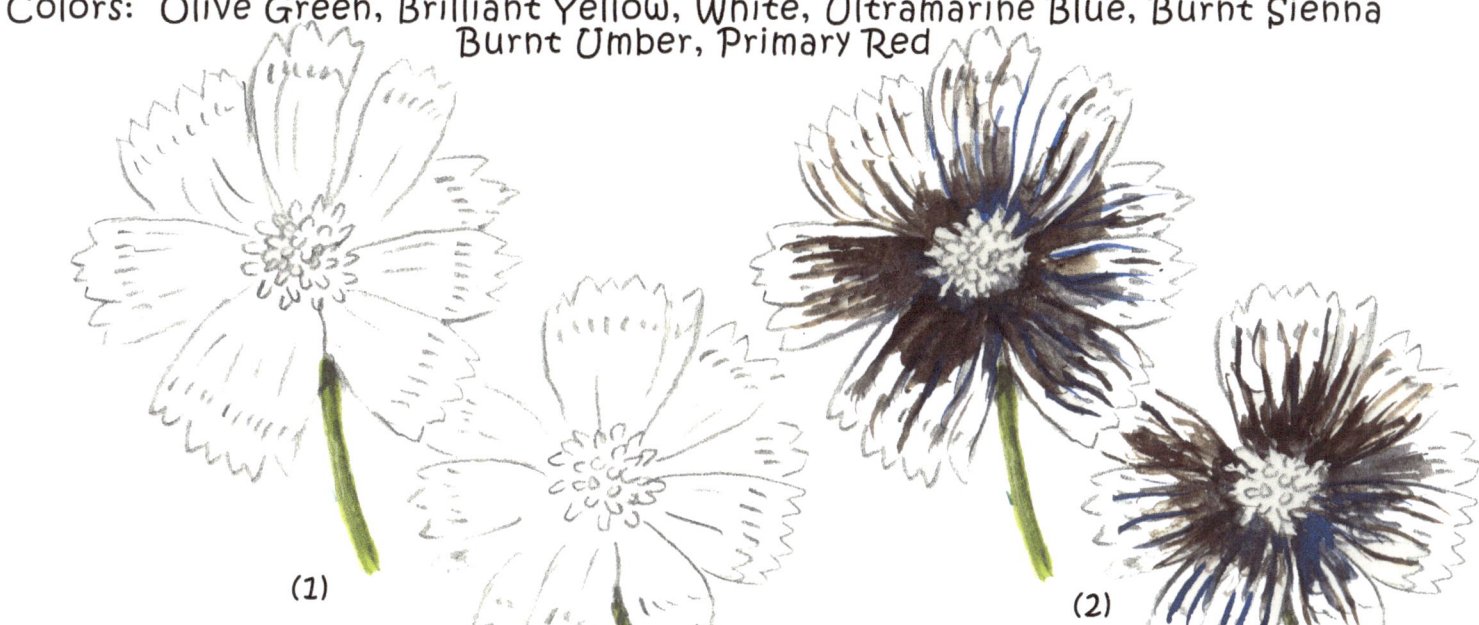

(1) Paint the stems with a mixture of Olive Green, Brilliant Yellow and White. Add Ultramarine Blue to make the shadow under the petals and along the right side of the stem. Put a highlight on the left side with a pale yellow green, almost white.

(2) For the petals -- first paint around the center and about a third of the way down the petal with a mix of Burnt Umber and Ultramarine Blue. A thinner layer is OK. Be sure to make dark lines radiating out toward the edges of the petals.

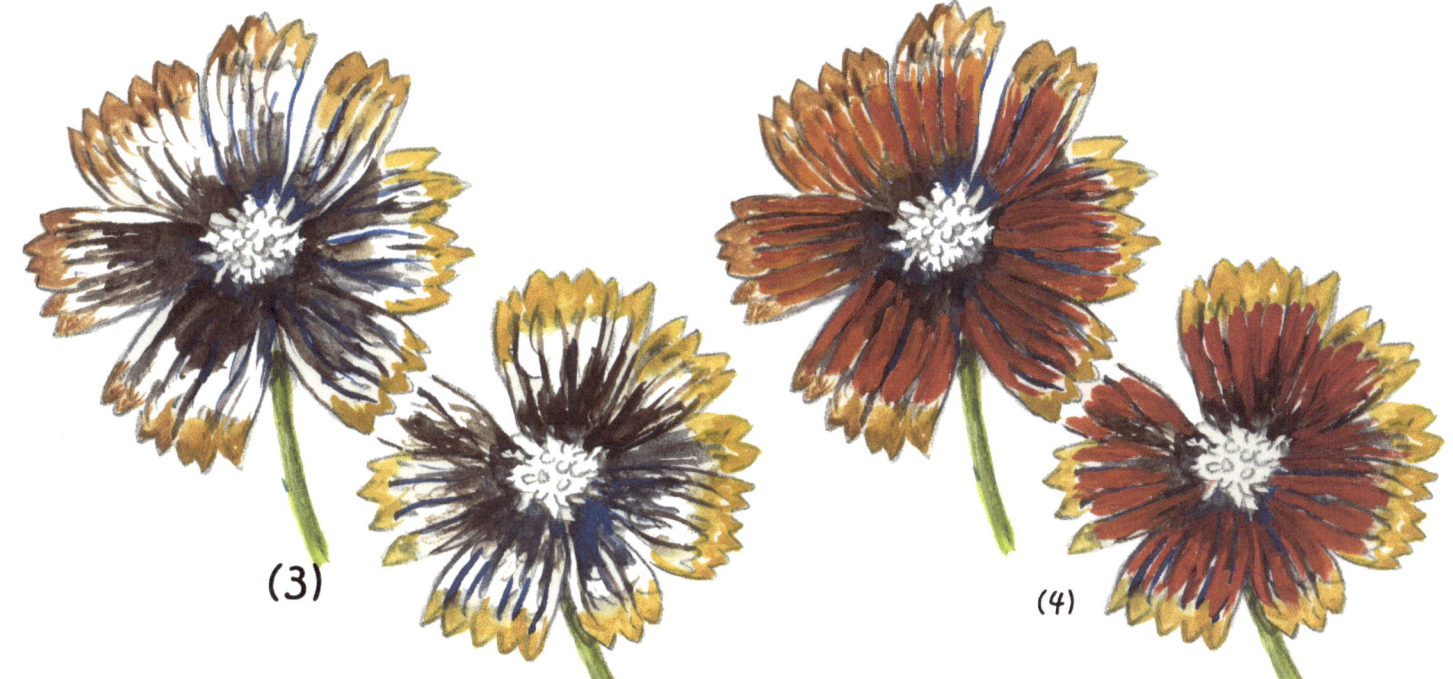

(3) Paint a mixture of Burnt Sienna and Brilliant Yellow on the tips of all the petals.

(4) Mix Red with Brilliant Yellow (more on the red side) and roughly paint the red orange parts of the petals, stroking along the length of the petals.

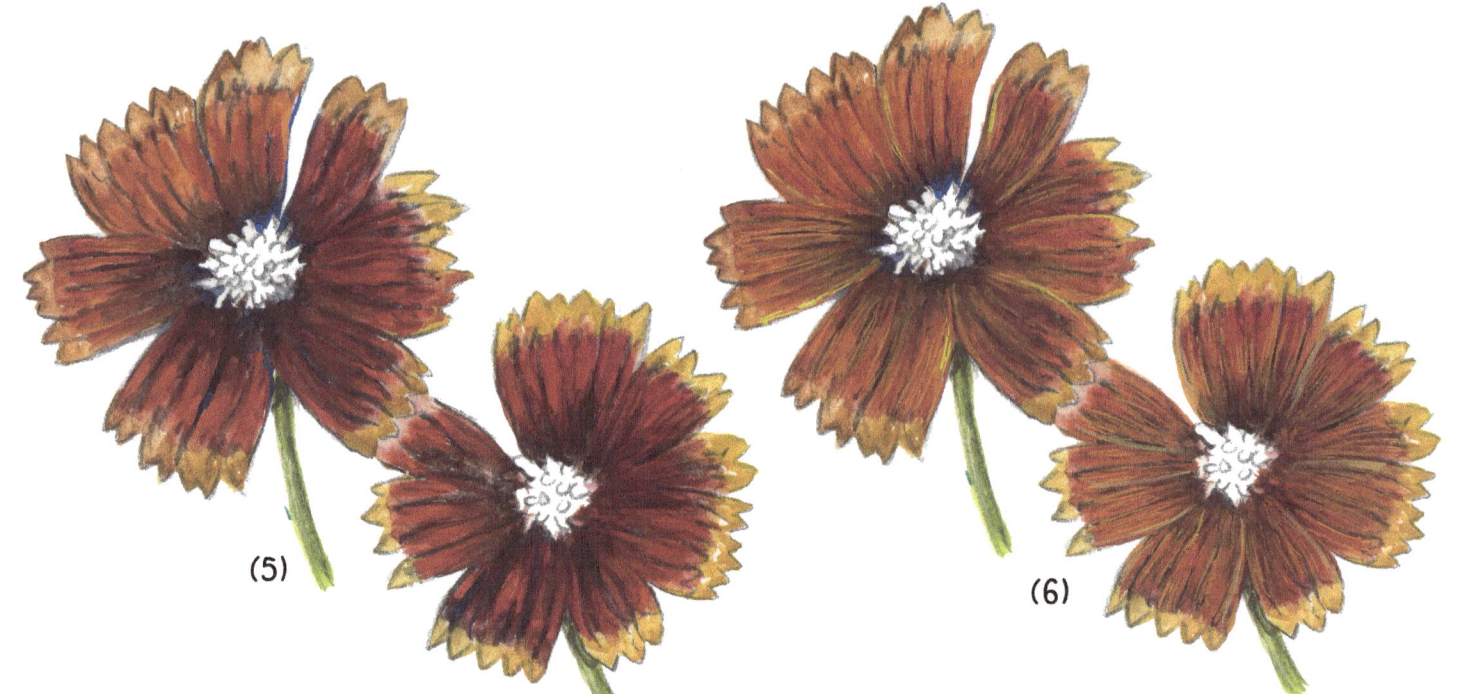

(5) With a damp brush blend the petals from the dark center out to the tips, rinsing your brush before you blend the lighter values at the tip. Don't entirely blend out the dark lines.

(6) To start the detailing, mix an orange, a little lighter than the red orange you painted the petals with before. Add a little more Brilliant Yellow to the Red. Paint the petals but don't entirely cover up the red orange you painted on them previously.

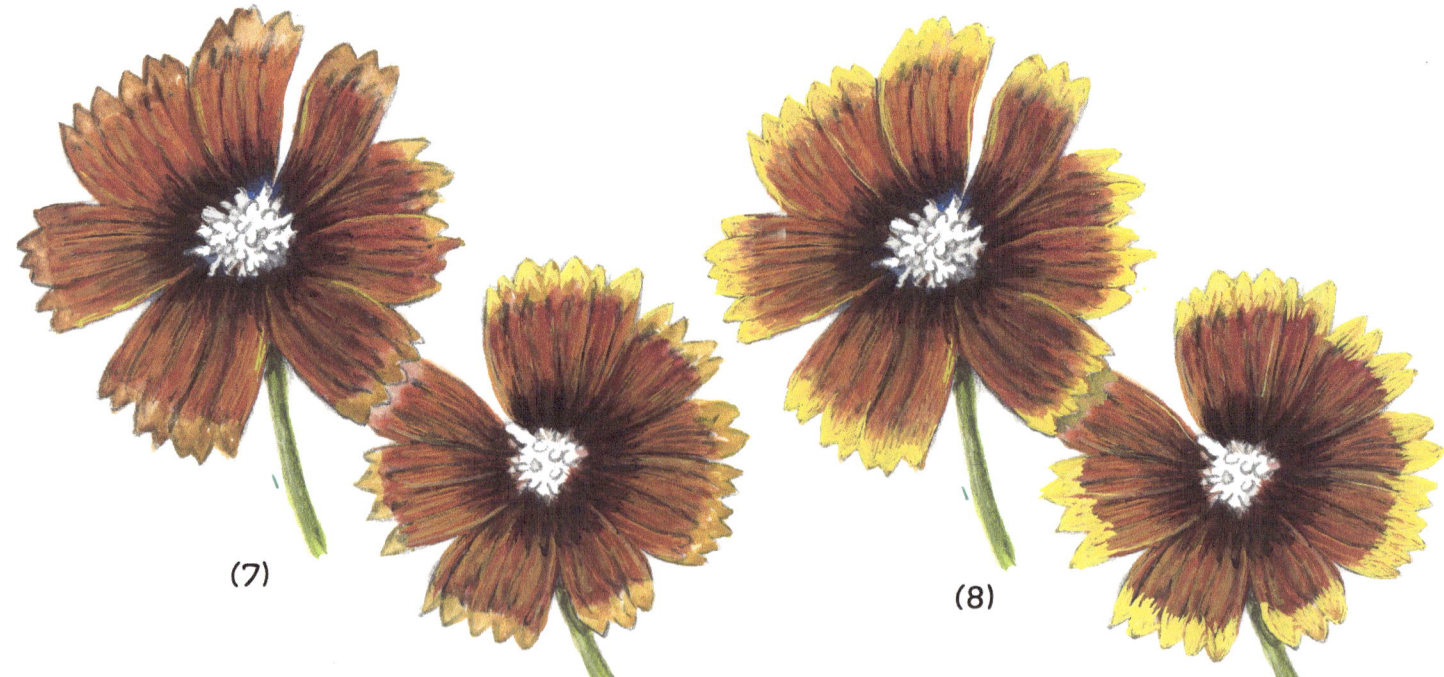

(7) Add highlights to the edges of some of the petals using a very light orange or yellow. Add deep shadows toward the center, and along some of the edges with a mixture of Burnt Umber and Ultramarine Blue.

(8) With a mixture of Brilliant Yellow and White, paint the tips of the petals leaving just a hair's breadth of the color underneath it so the petals will stand out from the paper. Gently blend the yellow into the orange with a damp brush.

Paint the centers a dark red, not as dark as the shadows on the petals. Dot the center with orange and then Ultramarine Blue. Let dry.

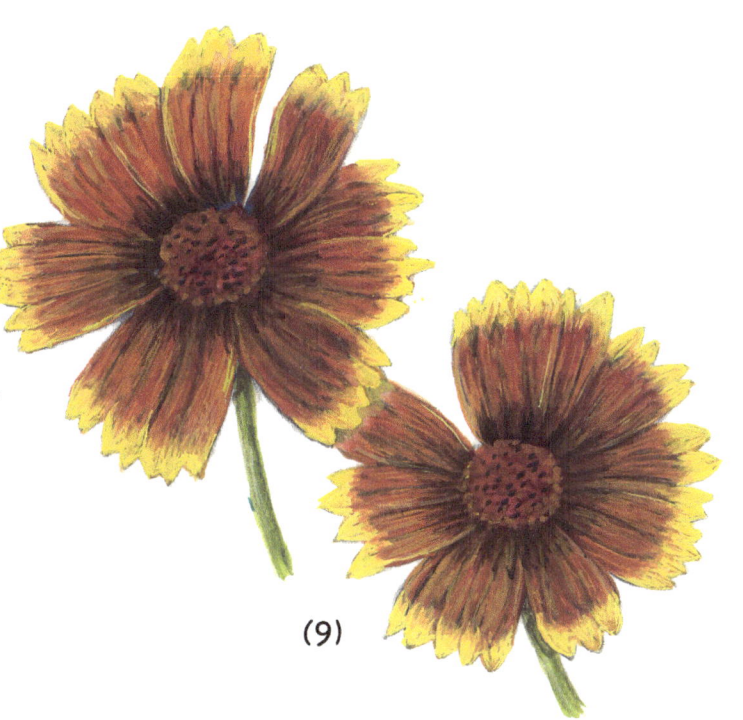

(9)

With a mixture of Brilliant Yellow and White, put in the anthers in the center of the flowers. Note how the ones around the outside of the center are more like lines, and the ones toward the center are dots.

(10)

Notes

Part 2

In Part 1 we dealt with using gouache to depict four colorful flowers. We concentrated on the flower heads, the colors and learning how to handle gouache to illustrate them.

In Part 2 we'll be dealing with the whole plant, in this case Trillium grandiflora. Stems, leaves, roots, cutaway views and parts of the plant at different times in its life cycle are very important parts of botanical illustration. You don't have to include everything in one illustration but you'll need to make a decision about what best shows the elements of your plant when you start working from a live specimen in Part 3.

So. . . Begin by transferring the Trillium grandiflora images to a sheet of smooth watercolor paper or board. Don't forget, this is a learning exercise. It's not important if your painting isn't perfect. Just be sure to learn from the experience and ENJOY the process!

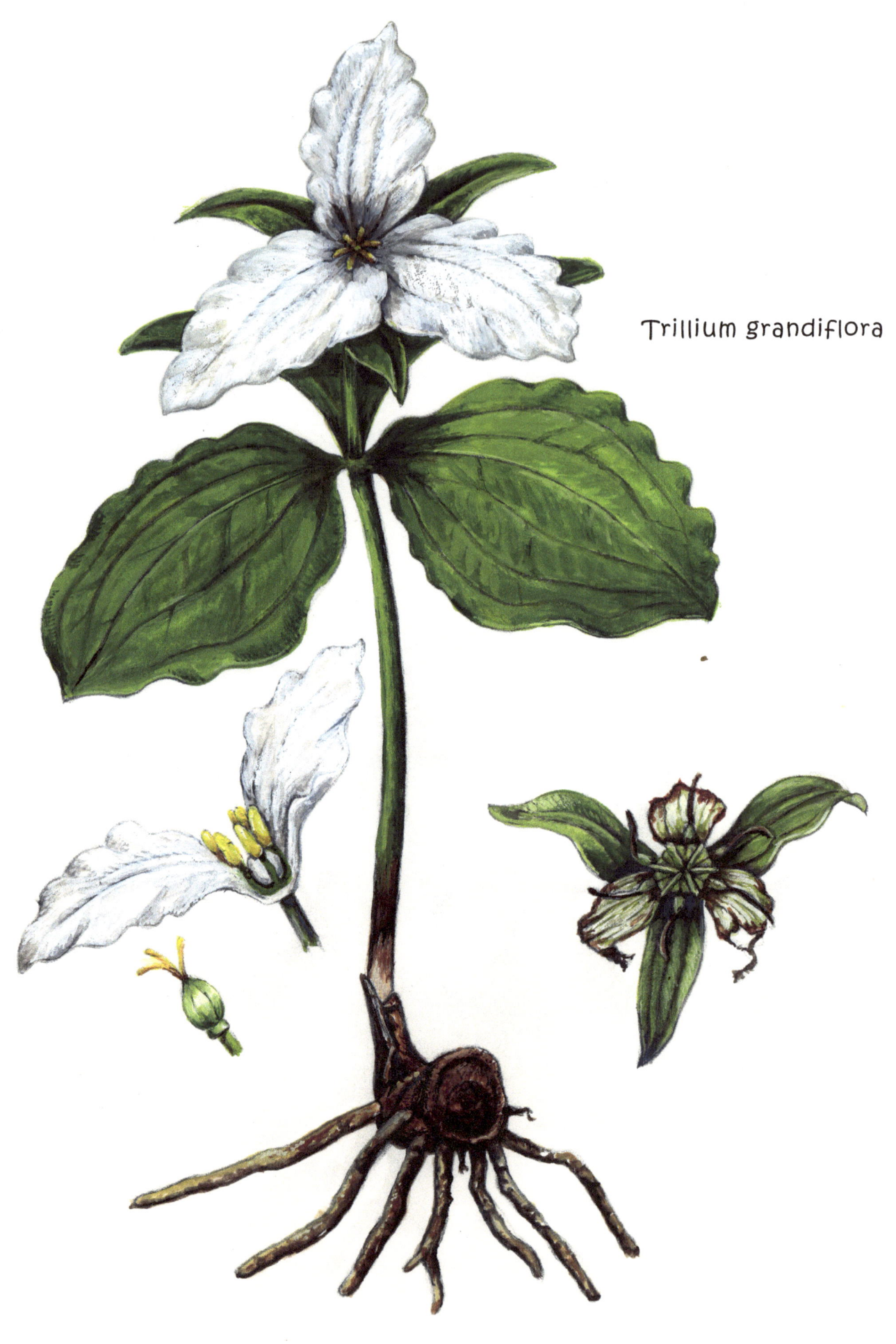
Trillium grandiflora

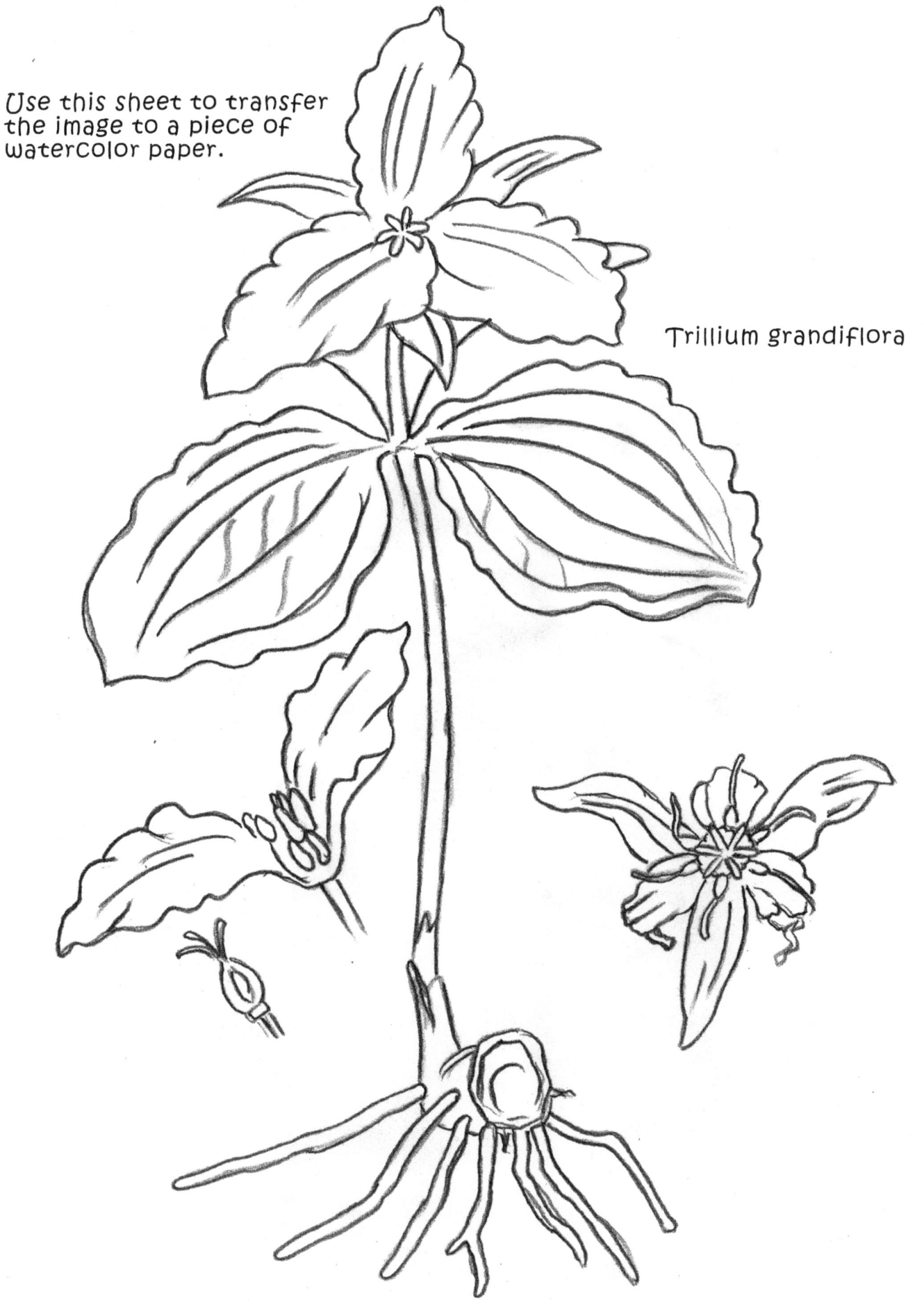

Trillium Stem

Colors Used:
Olive Green
Brilliant Yellow
Permanent White
Ultramarine Blue
Burnt Umber
Burnt Sienna

Mix Olive Green, Brilliant Yellow and White to paint the stem most of the way down on the left side. stop here (1)

Add Ultramarine Blue to your mixture and paint the right side of the stem. Also, paint a shadow at the top of the stem, underneat the leaves. (2)

Blend the two sides together with a damp brush. (3)

Below the green blend in some Burnt Sienna, and below that blend in some Burnt Umber. Blend in a little white on the left side of the stem for a highlight. (4)

For the bottom of the stem that's generally under the soil line, mix White with a little Burnt Sienna. Note that this becomes lighter as it goes down. To detail this section paint in some delicate striations with Burnt Sienna using your liner brush. (5)

Trillium Leaves

Colors used: Olive Green, Brilliant Yellow, Permanent White, Ultramarine Blue, Burnt Umber

Use a dark value of Burnt Umber mixed with Ultramarine Blue to paint in the veins of the leaves so you don't lose them when you start painting the green. Don't forget the three smaller leaves (sepals) right under the petals. Mix a medium green for the leaves with Olive Green, Brilliant Yellow and White. Roughly paint in the green areas of the leaves. This first layer of paint can be a little thinner.

Don't worry about getting this step perfect. Just cover up most of the white of the paper.

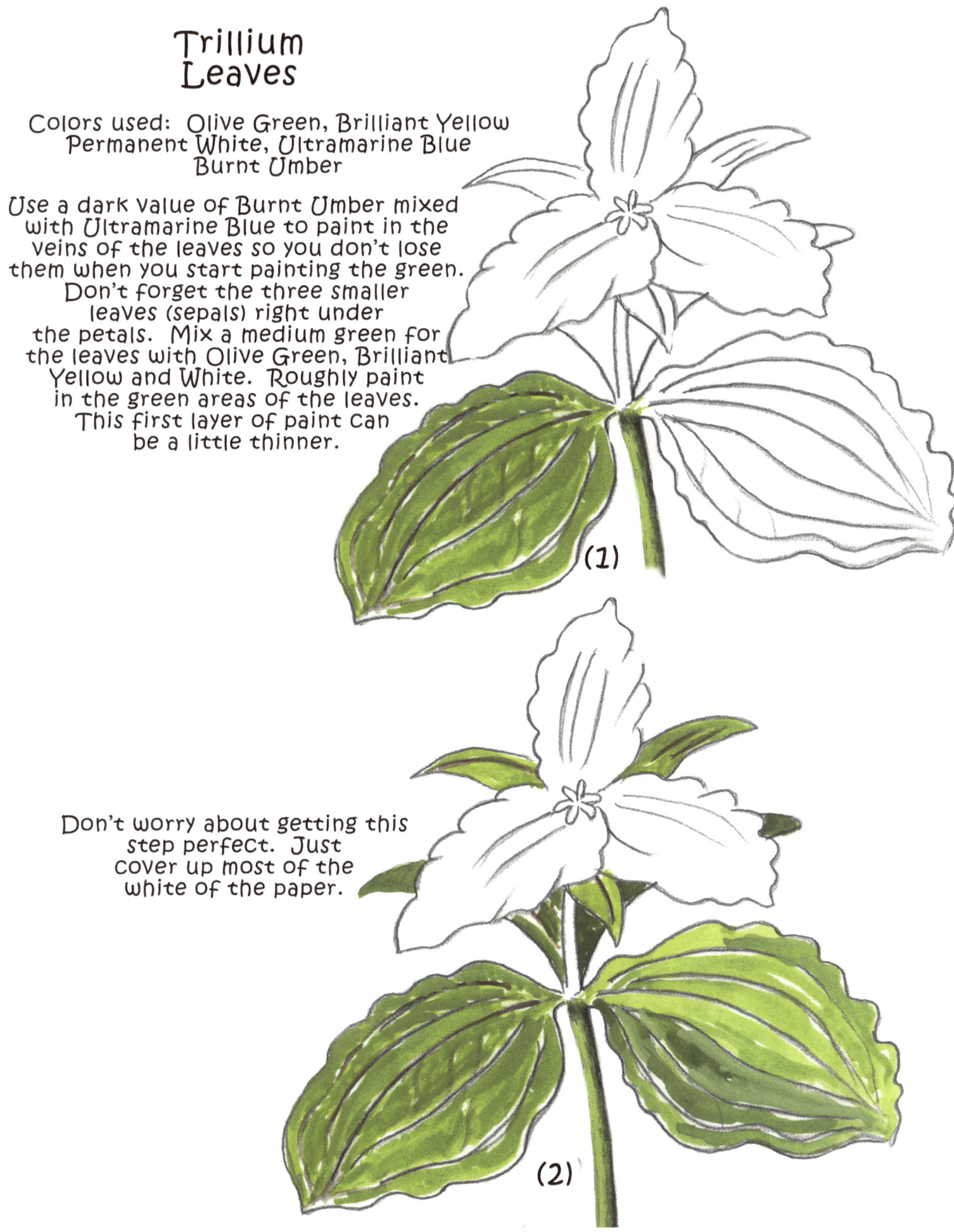

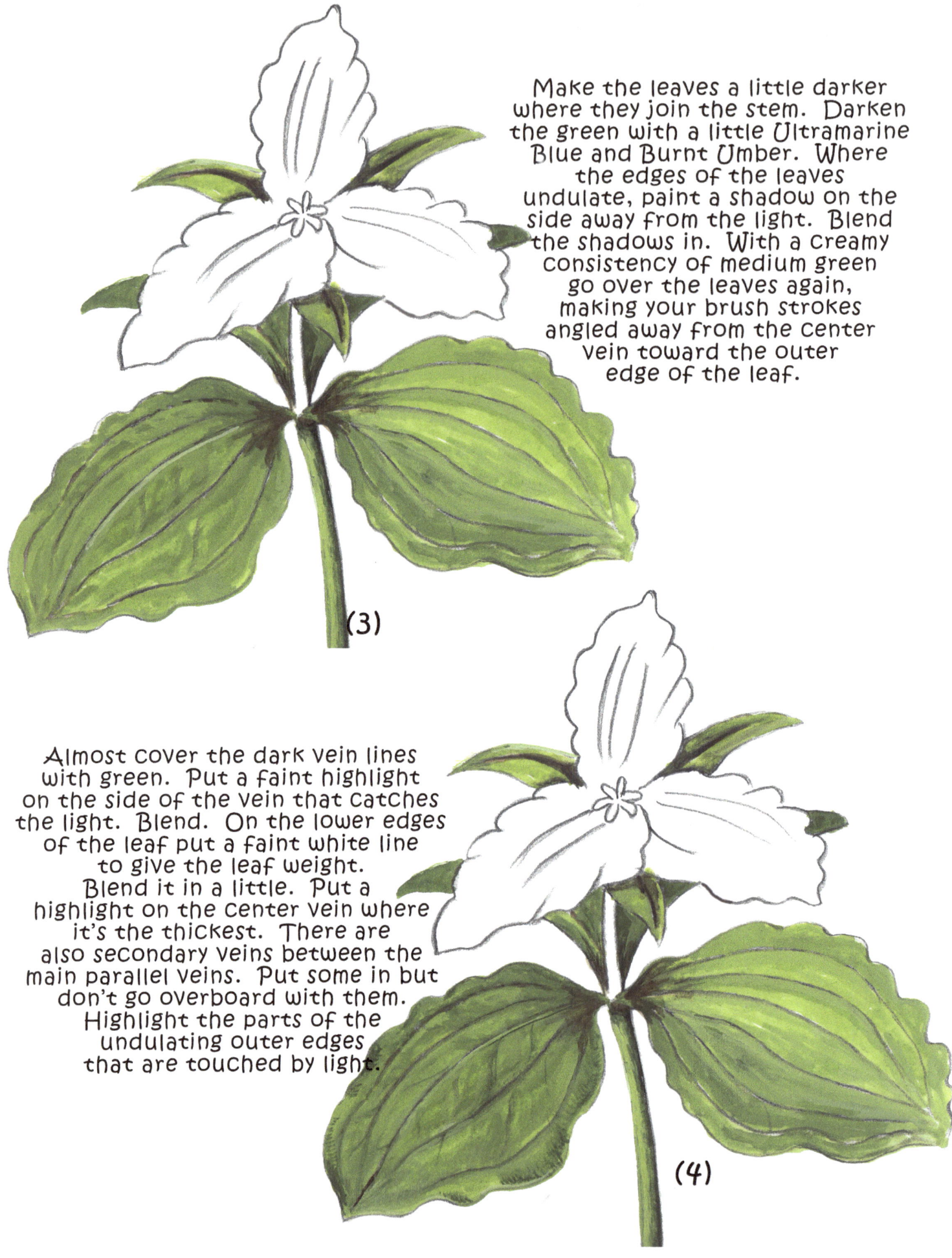

Make the leaves a little darker where they join the stem. Darken the green with a little Ultramarine Blue and Burnt Umber. Where the edges of the leaves undulate, paint a shadow on the side away from the light. Blend the shadows in. With a creamy consistency of medium green go over the leaves again, making your brush strokes angled away from the center vein toward the outer edge of the leaf.

(3)

Almost cover the dark vein lines with green. Put a faint highlight on the side of the vein that catches the light. Blend. On the lower edges of the leaf put a faint white line to give the leaf weight. Blend it in a little. Put a highlight on the center vein where it's the thickest. There are also secondary veins between the main parallel veins. Put some in but don't go overboard with them. Highlight the parts of the undulating outer edges that are touched by light.

(4)

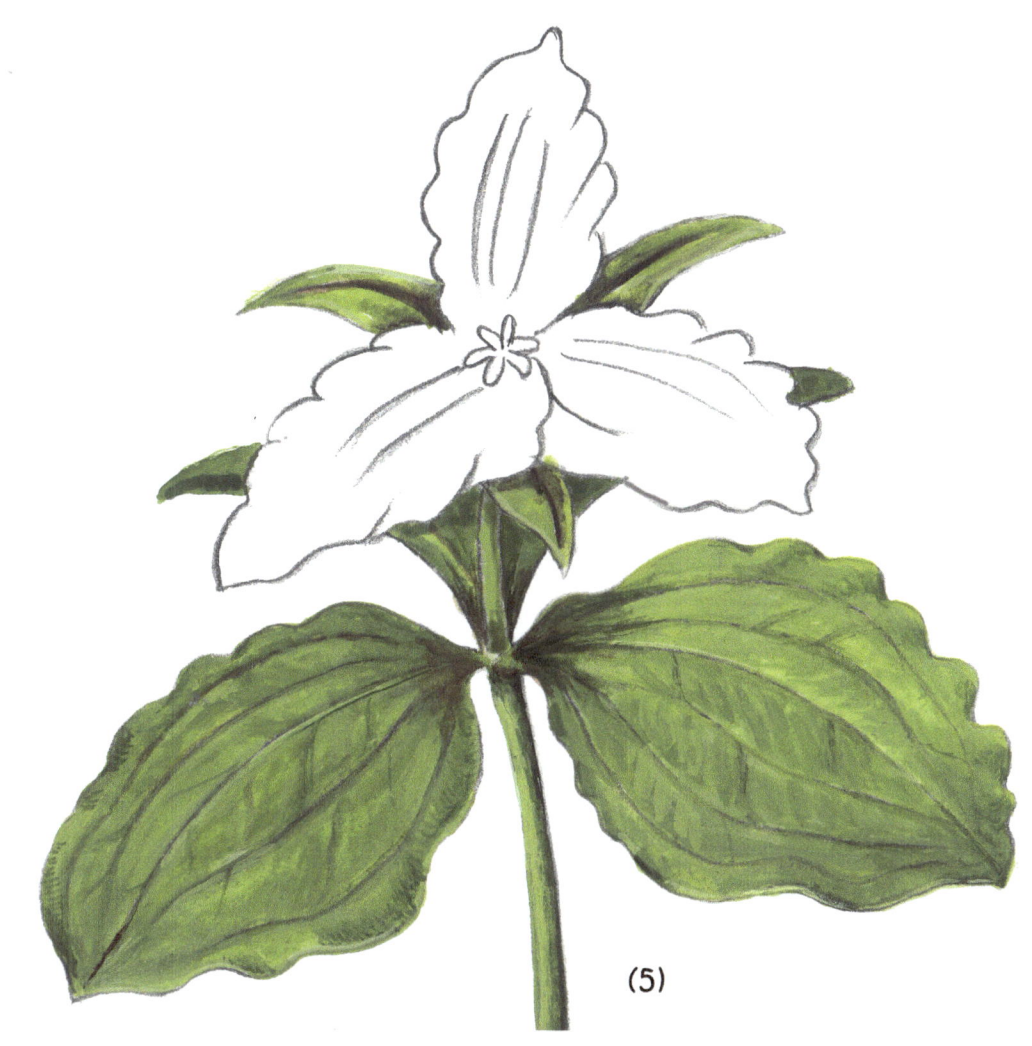

(5)

Paint the upper part of the stem above the leaves, shading it at the top and bottom. Make sure the leaf behind it is dark enough so the stem stands out.

Trilium Root System

Colors: Ultramarine Blue, Burnt Umber, Burnt Sienna, Permanent White

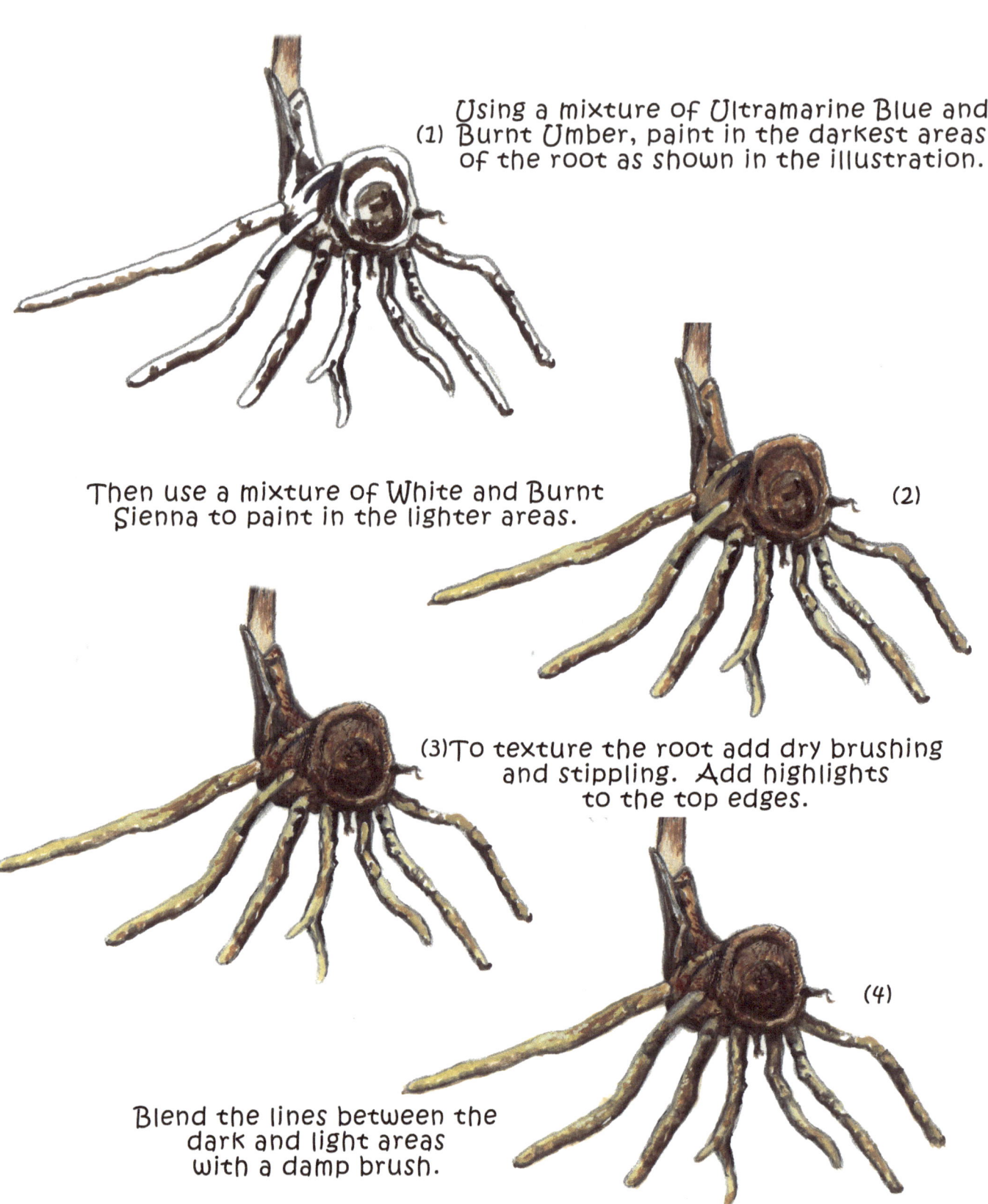

(1) Using a mixture of Ultramarine Blue and Burnt Umber, paint in the darkest areas of the root as shown in the illustration.

Then use a mixture of White and Burnt Sienna to paint in the lighter areas. (2)

(3) To texture the root add dry brushing and stippling. Add highlights to the top edges.

Blend the lines between the dark and light areas with a damp brush. (4)

Trillium Petals

Colors used: Permanent White, Ultramarine Blue, Burnt Umber, Brilliant Yellow, Burnt Sienna

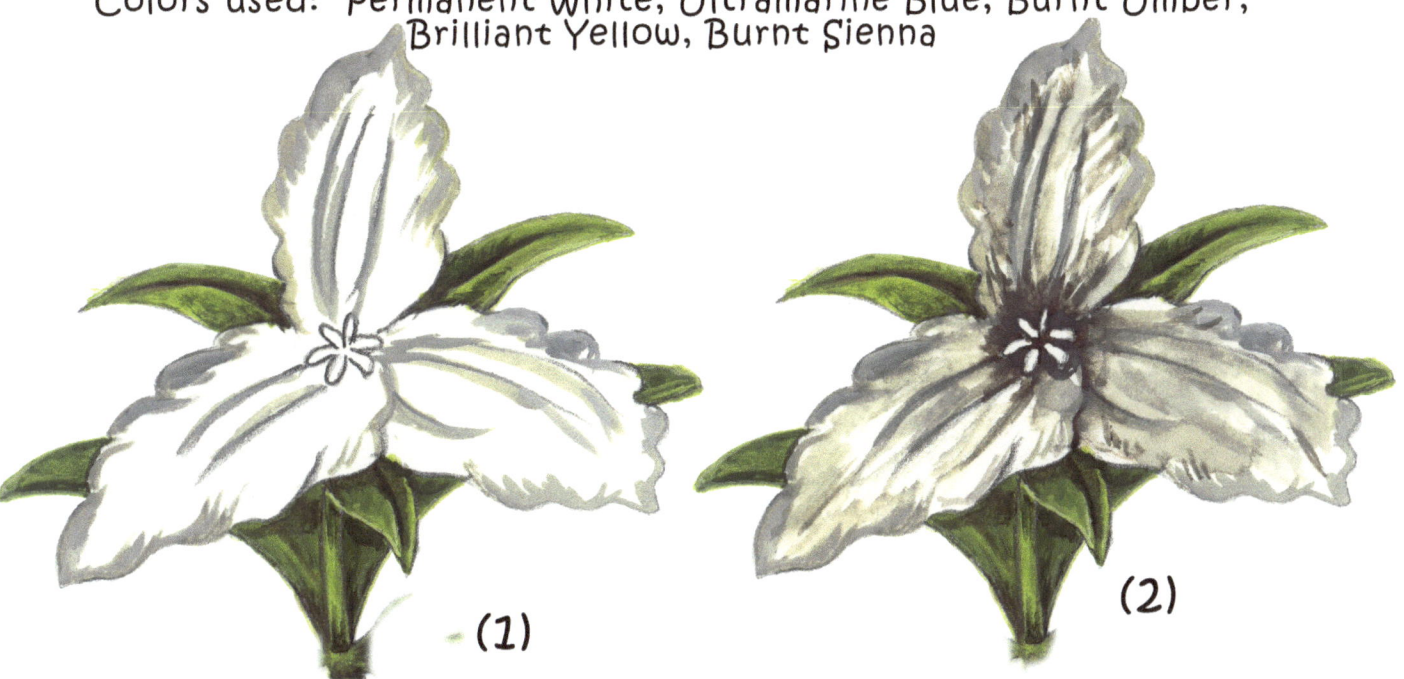

(1) Mix a medium gray color with Ultramarine Blue, Burnt Umber and Permanant White. Use a little more blue than brown. Paint the blue gray mixture on the outside edges of the petals and also along the parallel veins.

(2) Add more shading -- a little lighter gray this time all over the surface of the petal. It now looks like a gray flower. Paint a very dark value in the center.

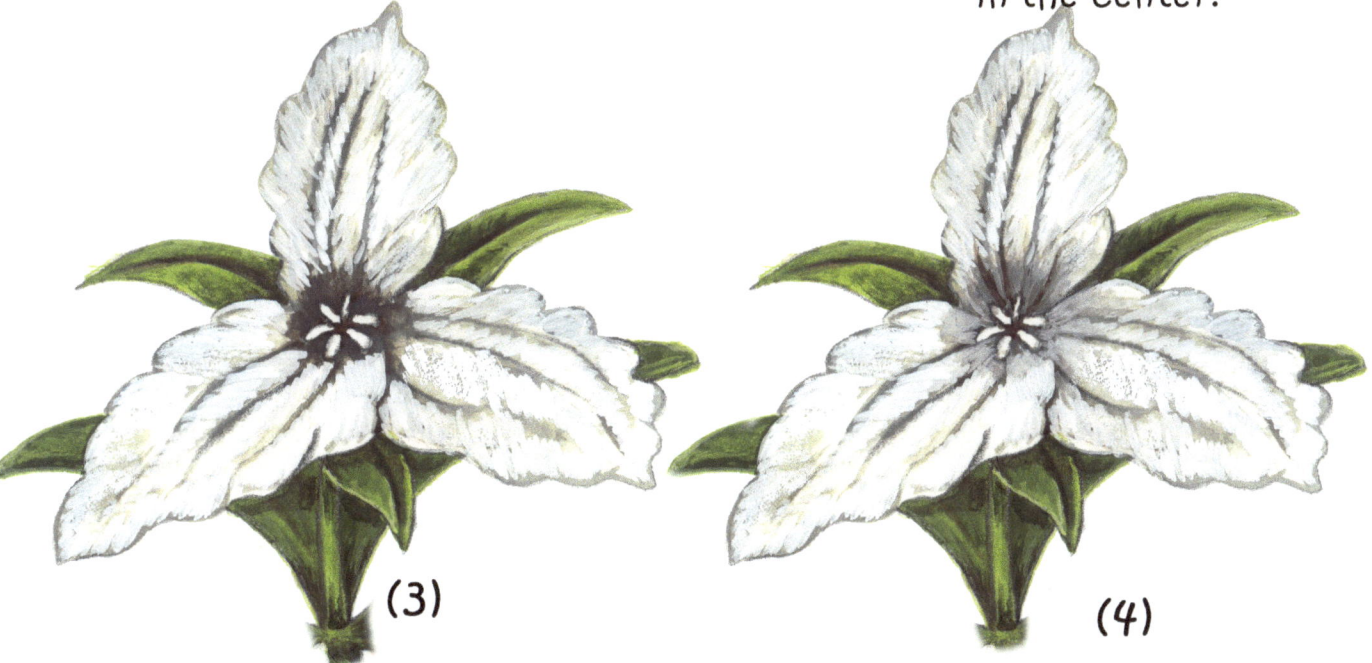

(3) With fresh, thick white paint stroke the paint from the center vein of the flower out to the edges at a slight angle, leaving just a hair's breadth of the gray at the edges showing. The petal veins shouldn't be completely covered.

(4) To paint the center of the flower, paint a medium gray mixture over the darkest part of the center, remembering to make the strokes go outward toward the edges of the petals. Blend the gray into the almost black of the center and also into the almost white as it leaves the interior of the throat of the flower.

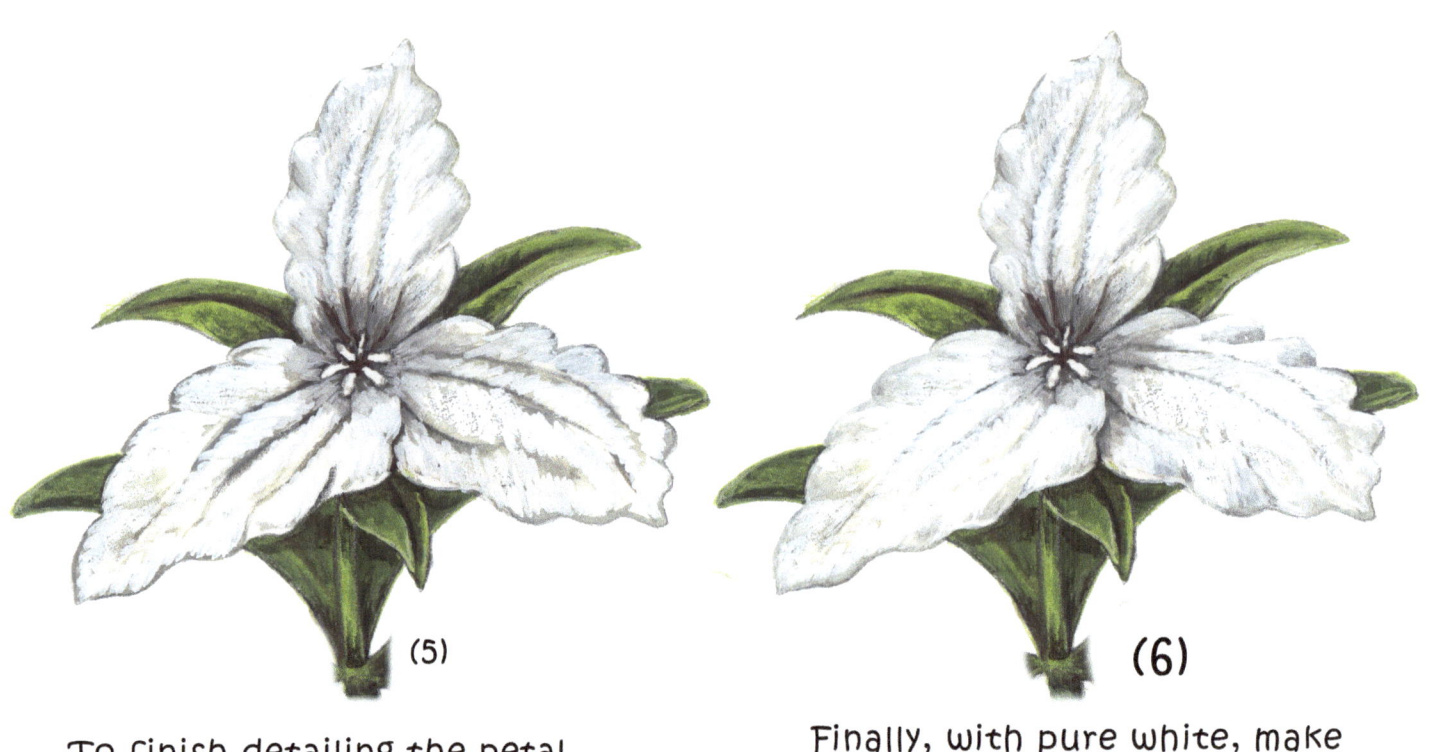

(5)

To finish detailing the petal, take pure white and make small strokes going outward toward the petal edges, coming very close to the dark veins and making them narrower and narrower. On the side of the vein away from the light make a faint shadow.

(6)

Finally, with pure white, make some delicate strokes over the veins, not enough to entirely cover them. Soften the outside edges of the petals but leave them dark enough so that the petals stand out from the paper. Where the petal edges undulate make a light shadow on the side away from the light. Blend with a damp brush.

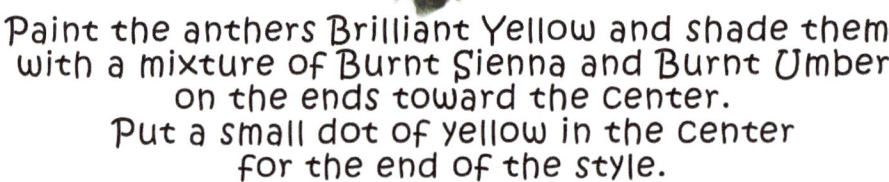

(7)

Paint the anthers Brilliant Yellow and shade them with a mixture of Burnt Sienna and Burnt Umber on the ends toward the center. Put a small dot of yellow in the center for the end of the style.

Trillium
Cutaway View and Ovary

Colors Used: Permanent White, Olive Green, Brilliant Yellow, Ultramarine Blue, Burnt Sienna, Burnt Umber

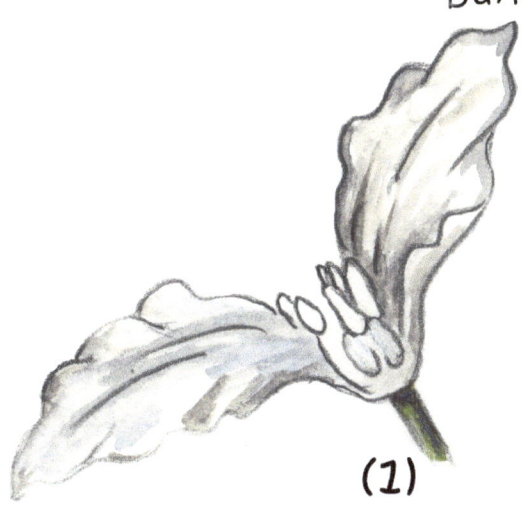

(1)

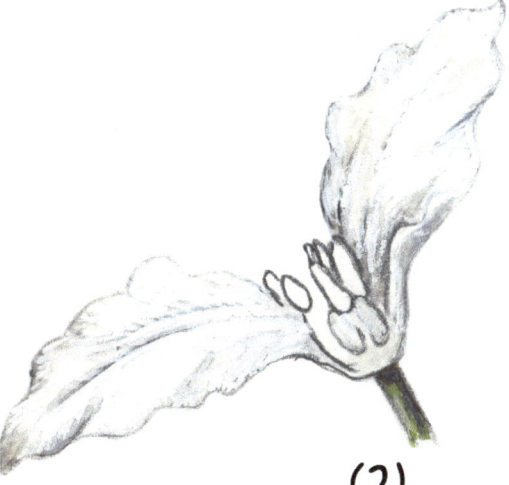

(2)

Paint the stem first with a mixture of Olive Green, Brilliant Yellow and Permanent White. Add the shadow at the top of the stem and on the right side with a mixture of Ultramarine Blue and Burnt Umber. Paint the ovary a light gray with darker gray at the bottom for shading. Paint the petals a light gray (a mix of Ultramarine Blue, Burnt Umber and White) and gently blend it into a darker gray toward the center and for the veins.

Use pure white to detail the petals, using small strokes angled from the center of the petal outward to the edges. Almost cover the vein lines and the outer edges. Make a little shadow on the undulating edges of the petal on the side away from the light.

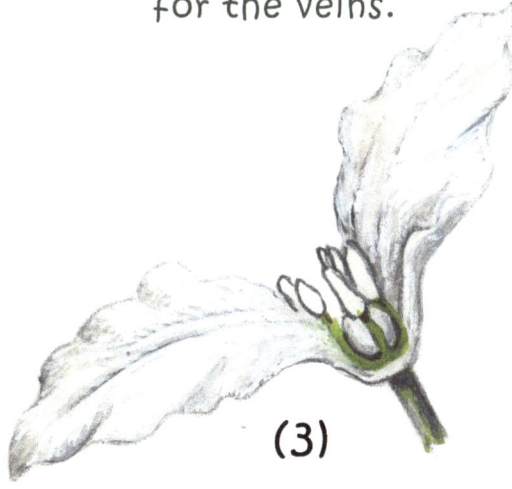

(3)

Paint the filaments yellow green, making a shadow under the anthers.

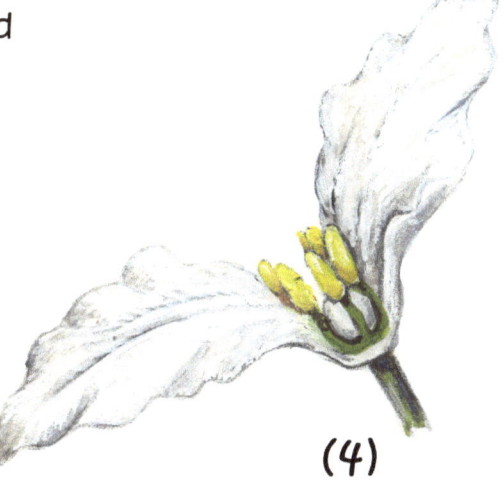

(4)

Paint the anthers Brilliant Yellow, adding a little Burnt Sienna mixed with Burnt Umber for the shading and put a little White toward the tips for highlights.

Ovary -- When I peeled away the flower I ended up with just the ovary.

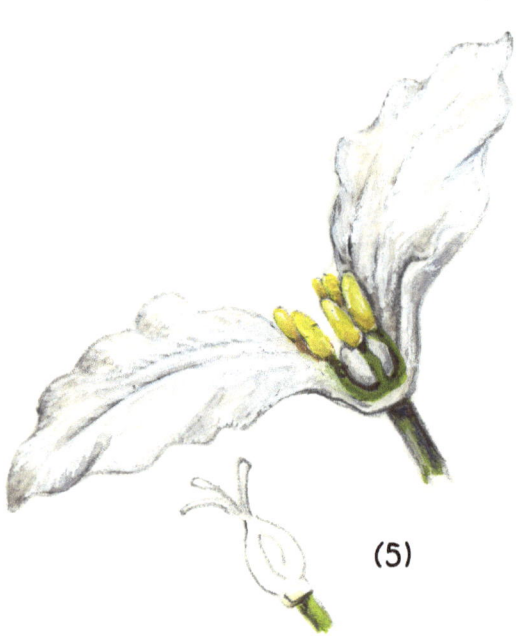

(5)

Paint the stem with the Olive Green, Brilliant Yellow and Permanent White mixture. Add the shadow with Ultramarine Blue and Burnt Umber.

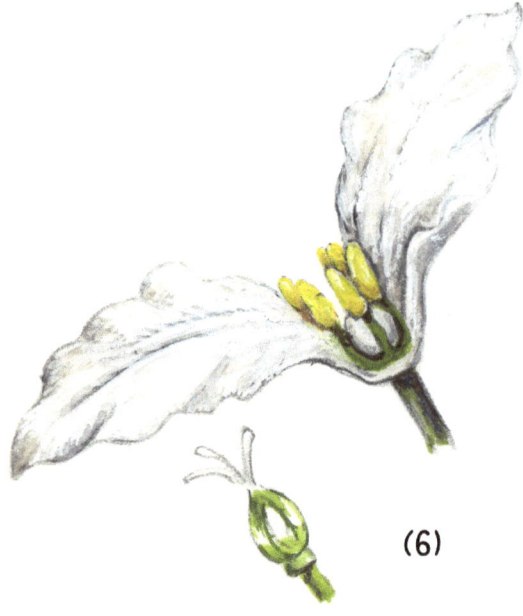

(6)

Using a darker green outline the ribs. Paint the rest of the ovary a medium green.
Highlight the middle of the ovary with White.

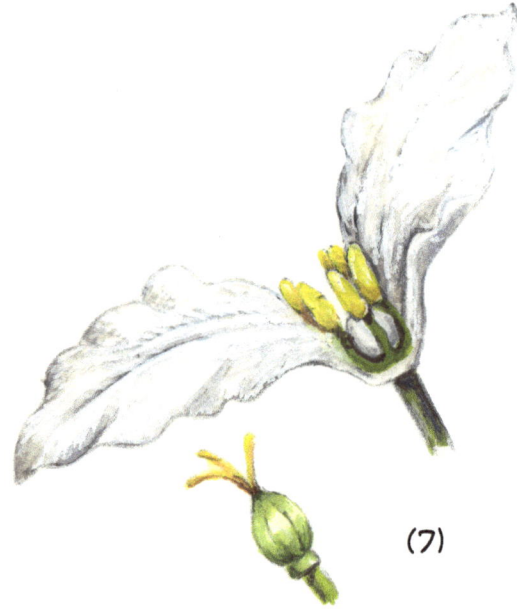

(7)

Blend in the highlight to model the round shape of the ovary. Paint the style with Brilliant Yellow using Burnt Sienna for shading.

Trillium
Overhead View of Spent Blossom

Colors Used: Permanent White, Brilliant Yellow, Olive Green, Ultramarine Blue, Burnt Sienna, Burnt Umber

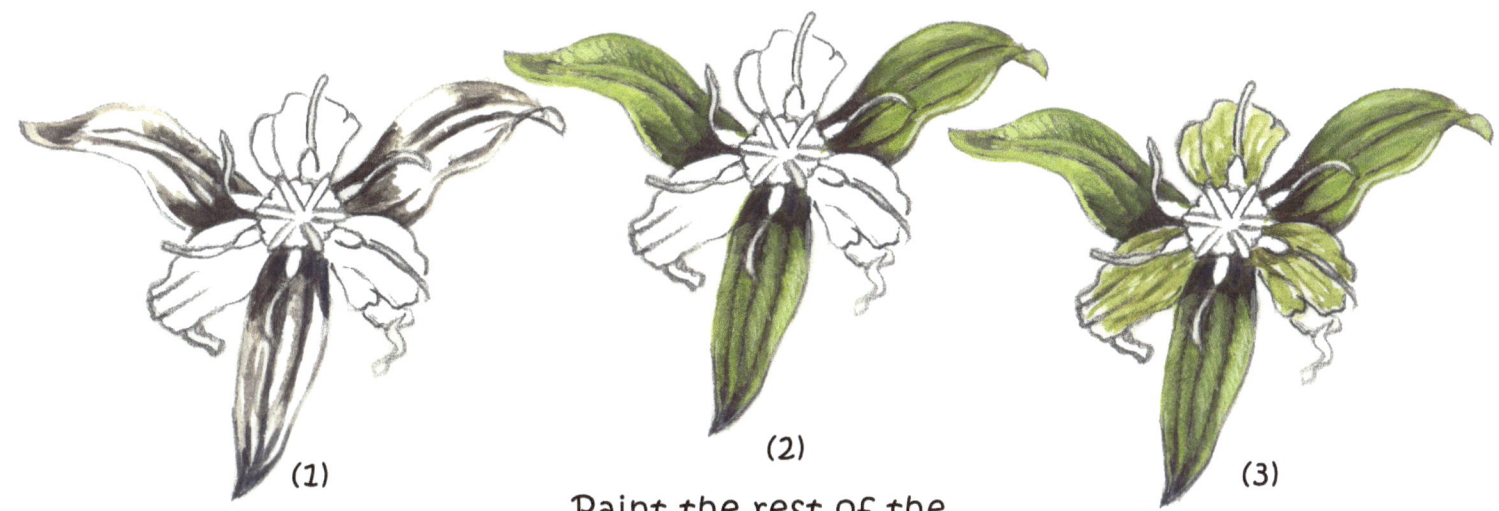

(1) Paint the dark shadow areas and the veins on the sepals with a mix of Ultramarine Blue and Burnt Umber.

(2) Paint the rest of the leaf with a medium value of green mixed with Olive Green, Brilliant Yellow and White. Blend the green into the shadows. Highlight the top parts of the leaf and the edges facing toward you.

(3) Next paint the shriveled white petals a pale green.

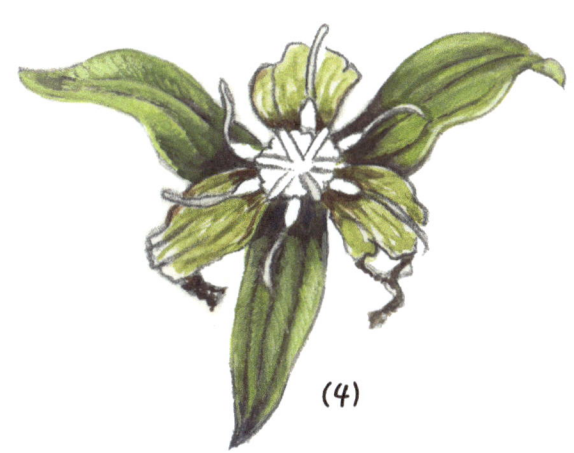

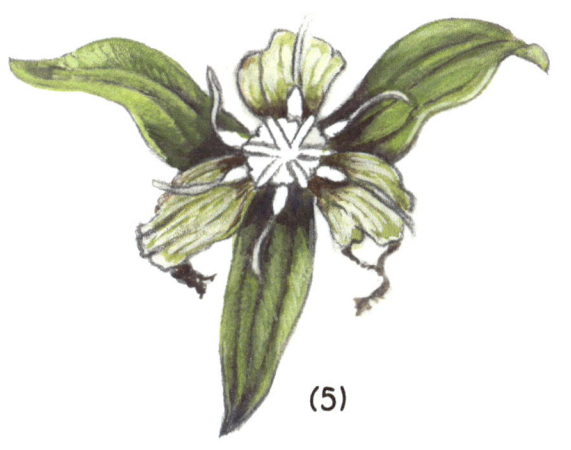

(4) Mix Burnt Sienna and burnt Umber and paint the shadows where the petals slip under the ovary. Use the same mixture to paint the dead crinkles on the tips of the petals.

(5) Using pure white paint in striping along the spent blossoms, being careful not to completely cover the green. Blend at the shadow line near the center.

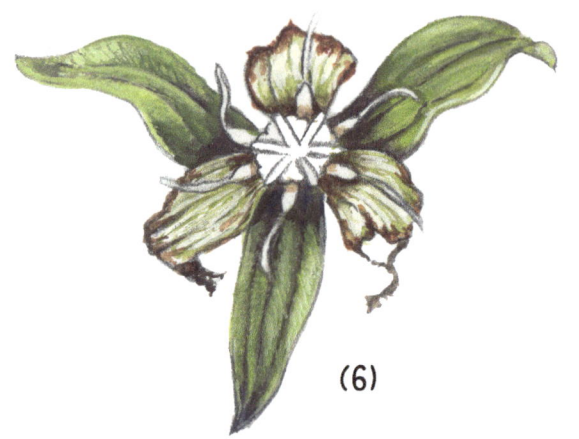

(6)

Use a mixture of Burnt Sienna and Burnt Umber for the dark spots and edges on the old petals. Blend with a damp brush.

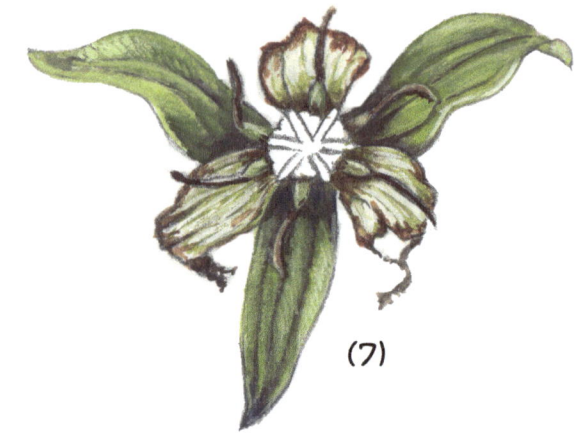

(7)

Paint the bases of the filaments light green, shading with a little Burnt Umber toward the center and on the side away from the light. Paint the filaments dark where they cross a light area, and light where they cross a dark area so they'll show up.

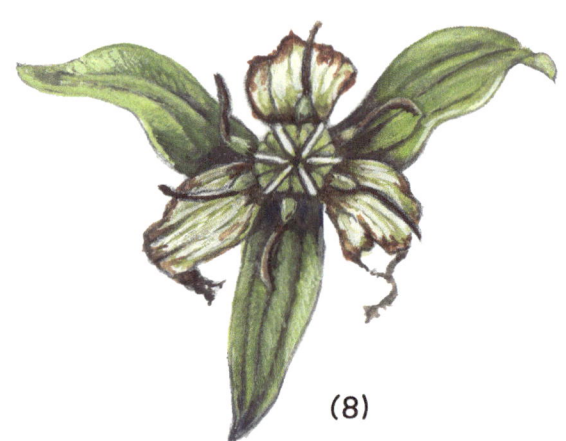

(8)

Paint the ovary a pale green. Add the faint dark lines and highlights.

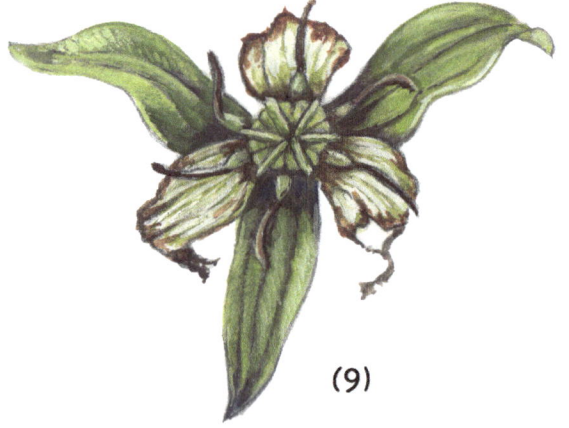

(9)

Paint the ridges on the ovary pale green, almost white, with a little green shadow on the side away from the light.

Notes

Part 3
On Your Own

Using a Live Specimen as a Subject

For your first illustrations, avoid flowers with a myriad of small petals like yarrow or chrysanthemum. They can be very difficult and frustrating to portray.

Observe! Observe! Observe!

Really look at the plant you've chosen. Turn it around and see it from different angles. What angle will show it off at its best! Use the list of questions on the next page to identify the things that differentiate this plant from others. For gouache paintings it doesn't pay to make a highly detailed pencil sketch because you'll be painting over it. If at all possible, when you get your drawing done, see if you can make a black and white copy of it for future reference.

Plan ahead -- be sure to leave enough room on the paper so the plant won't run over the edge.

Always remember that your specimen is a living thing, constantly changing, aging, bending toward the lilght. It might be wise to first start painting the blossom as that is most likely the part that has the shortest lifespan.

Don't forget to take a damp brush and lightly soften the outside edges. You could do this as you go along or wait until you're almost finished. Whatever works best for you!

Take a minute before you begin and use your imagination. Just for a minute pretend that it's 200,000 years in the future. Your plant has long ago become extinct. Someone, somewhere, runs across the name of your plant in an old, old book and plugs its name into their computer (or whatever device they'll have in those times) and the image that comes up is your painting. What does that person in the future need to know about the plant? Show them!

Questions to Ask When Starting
a New Illustration

What is the best angle? Look at the flower from all views to see how best to show off all of the elements of the plant. The viewer has to see as many of the details as possible.

In what order will you paint the elements? Usually you will paint the blossom first because that's the part that will fade first. Don't forget -- a living plant is ever changing, twisting toward the light, growing, changing with the amount of moisture. Try to get a good, qualilty drawing, but time is an issue. You may want to take a photo to remind you later but a photo can't be relied on for everything.

Stem -- Is it hairy, smooth, erect, prostate, straight, curved, does it have color variations?

Leaves -- How are they arranged on the stem? -- alternate, opposite, whorled? Is the surface textured (smooth or rough)? Are the edges smooth, toothed, lobed, undulating? Are there color variations? How are the veins positioned? Very important -- How are the leaves attached to the stem?

Roots -- Will you include the roots? Roots vary widely and can be very interesting. Try to expose them for as short a time as possible to save the plant.

Flowers -- Check the number of petals, how are the petals arranged? Are the edges smooth or jagged? Are there color variations on the petals? How many anthers, stamens? Does the style show? Is the surface of the petal smooth or wrinkled?

Notes

Wrapping Things Up!

Botanical Illustration can be very rewarding. I hope you use this course as a basis for continuing to explore and experiment with new techniques and materials to portray the plants around you.

Don't Forget . . .

Accuracy through Observation!

Please check out Sound of Wings Studio, www.soundofwings.com, for upcoming courses in Natural Science Illustration in Gouache. The classes are available as computer dowloads, DVD's and now books on Amazon!

Thanks!

Sandy

Sandy Williams

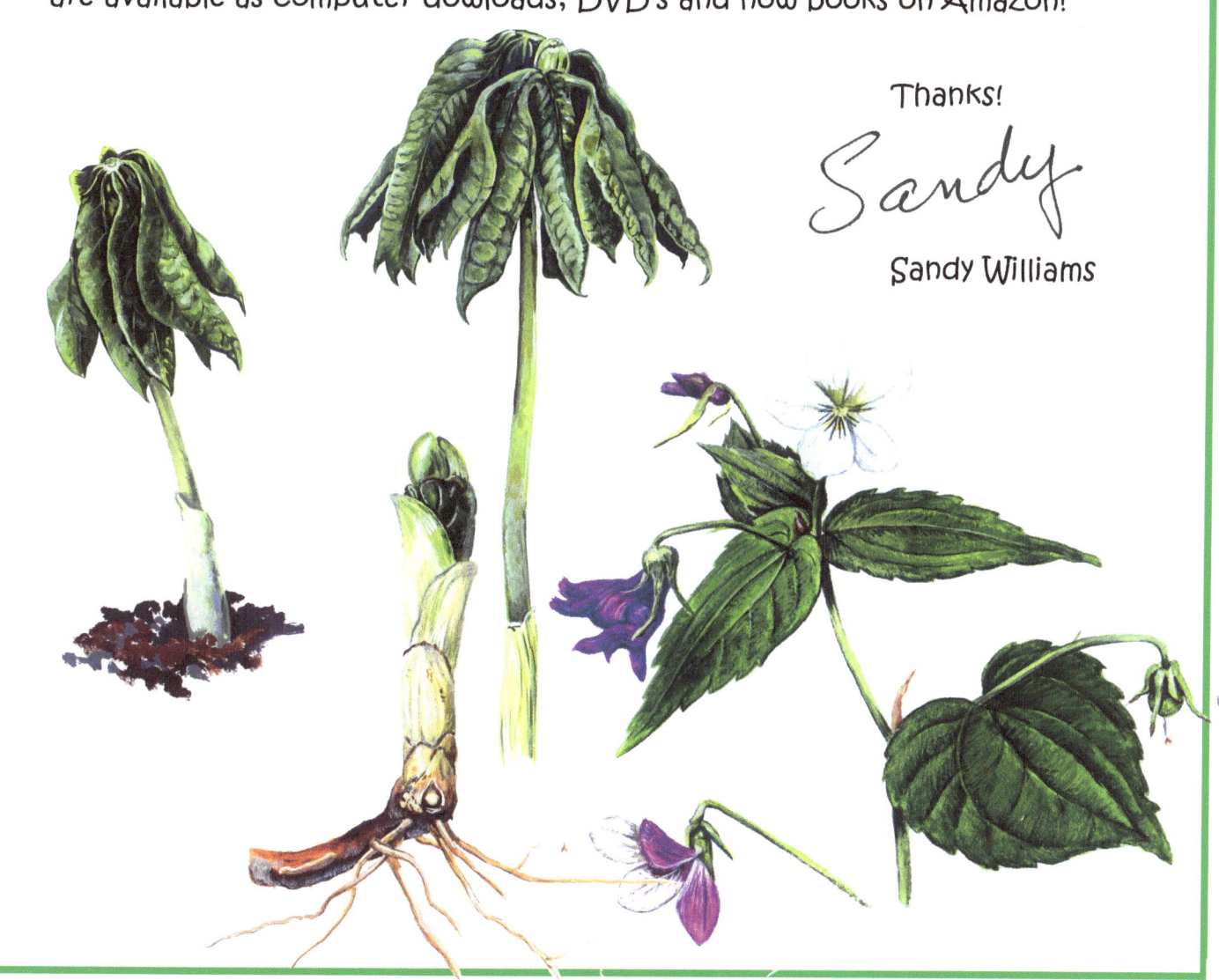

Notes

www.ingramcontent.com/pod-product-compliance
Lightning Source LLC
Chambersburg PA
CBHW050834180526
45159CB00004B/1899